CONTEMPORARY ART IN AFRICA

Contemporary Art in Africa

ULLI BEIER

FREDERICK A. PRAEGER, *Publishers*
New York · Washington · London

FREDERICK A. PRAEGER, *Publishers*
111 Fourth Avenue, New York, N.Y. 10003, U.S.A.
77–79 Charlotte Street, London, W.1, England

Published in the United States of America in 1968
by Frederick A. Praeger, Inc., Publishers

Library of Congress Catalog Card Number: 68–19132

Printed in Great Britain

FOR

CHINUA ACHEBE

ONUORA NZEKWU

LAZARUS UKEJE

Contents

Illustrations

Acknowledgments for photographs:

Jimoh Buraimoh Colour plate X

Michael Friedell Colour plate XI

Stephen Moreton-Prichard 46, 49, 50, 51 Colour plates IV, V

Frank Speed 3, 4, 92, 93, 94, 95, 96, 97

Valerie Wilmer 13, 14, 15, 32, 52, 53, 54, 55, 56, 58, 59, 60, 61, 62,
 67, 68

All other photographs by the author

Preface

There has been a profusion of books on traditional African art in recent years. Though many of these are excellent they tend to create the impression that artistic expression is a thing of the past in Africa and that nothing of value is being produced today. The simple reason for this is that modern art is a fairly new phenomenon in Africa. In my own book *Art in Nigeria 1960* I could merely describe the first hints of contemporary art, for the real breakthrough had hardly begun. Now, only seven years later, the artistic scene is very exciting, and not only in Nigeria. It is much too early to write a history of modern art in Africa, and in any case I would not pretend to be qualified to do so. This book can only be a personal account of the artists I knew while living in Africa and whom I met in various capacities as critic, editor, director of an art gallery—but above all as someone who loves art and feeds on it, and wants to be surrounded by it. The field is already vast: Evelyn S. Brown, in her *Africa's Contemporary Art and Artists* published by the Harmon Foundation, lists more than three hundred artists. Many of these, I feel, do not merit discussion, but even the good ones are too numerous to be discussed in detail in a book of this scope. I have aimed at a representative collection rather than a comprehensive one. My choice was of course dictated by my personal preferences, but also by my particular limitations. For seventeen years I was a tutor in the Department of Extra-Mural Studies of the University of Ibadan, Nigeria. It is obvious that I have a closer knowledge of art in Nigeria than in, say, Kenya. Moreover, I have spent the last ten years in Oshogbo, Western Nigeria, where I was directly involved in these developments. Rather than disguise these facts and attempt to restore some kind of artificial balance, I have decided to present African art as I know it. In Part One of this book, therefore, I have tried to give a more objective picture of the renaissance of African art as exemplified by those artists whom I know best, whom I exhibited in the Mbari galleries of Ibadan, Oshogbo, and Lagos, and whose work I discussed in the magazine *Black Orpheus*. In Part Two I have given a more personal

account of the artists in one particular town. Here I have been able to supply a much more detailed background to the artists' work and place them much more firmly in their local context. To the many artists, particularly the good ones, whom I was unable to mention in this book I extend my apologies. No harm was intended, and no claim is made that this is an exhaustive or objective survey. It is hoped, however, that this book will create interest in the subject at home and abroad and that it will prove to be only the forerunner of other, more detailed, studies.

CONTEMPORARY ART IN AFRICA

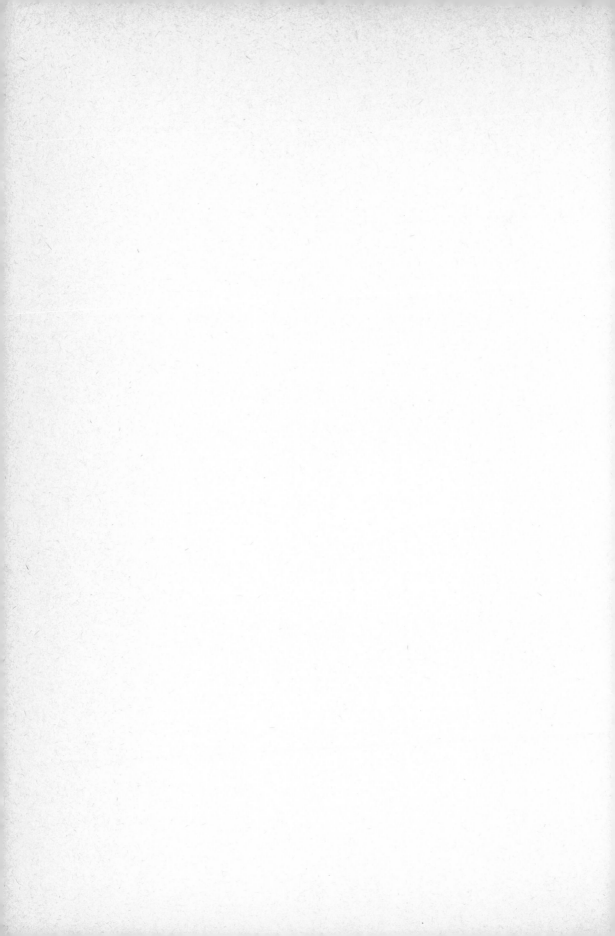

Introduction

'We are in at the death of all that is best in African Art. . . .' The quotation is from William Fagg and it describes the well-known tragic phenomenon in Africa. All over Africa the carvers down their tools. The rituals that inspired the artist are dying out. The kings who were his patrons have lost their power.

Art forms flourish and decay all over the world and at all times. Why are we so painfully aware of the decline of the African tradition? Partly, I think, because the decline follows so soon on our discovery of this art. Perhaps no other foreign art has had such a powerful impact on European art, has produced such revolutionary results. It is with a feeling of shock then, that we realise that the great vitalising influence, the most vigorous stimulus European art has received, comes from a dying culture.

We also have feelings of guilt. The destruction of traditional African values is due to a large extent to contact with Europe, or rather to the nature of this contact. It is customary to blame the decline of African cultures on missionaries, colonial administration and industrialisation—in that order. Little attention has been focused on the inherent weaknesses of the African cultures themselves or on the fact that many were degenerate before the decisive European contact. The court art of Benin, for example, had declined long before the British punitive expedition destroyed the city in 1897. What is the guilt of the missionary? He has been accused of mis-understanding and misinterpreting African culture, of un-intelligently denouncing African art as 'idolatrous' and of brutally burning it. This is correct, but it must also be seen in a wider context. The prejudices the missionary brought with him to Africa were not simply Christian, but European prejudices. The missions were mainly established in Africa during the nineteenth century, when European prejudice was at its peak. In those days even the artists saw nothing of interest in Africa. I do not know whether Constable or Corot ever saw an African mask, but I am fairly certain that if they had they would have regarded it with indifference.

3

European prejudice towards the 'primitive' races built up slowly. The Portuguese who visited Benin in the fifteenth century had no contempt for the Binis. They described Benin with the same sense of curiosity which a traveller would naturally bring to any foreign culture. When Vasco da Gama encountered the Hottentots in 1497 he was mainly interested in whether they had gold or ivory or silk to trade with. When they shook their heads at every item he showed them, there was a moment of awkwardness until the Hottentots brought out their flutes and played and danced to entertain the Portuguese visitors. With perfect courtesy, Vasco da Gama ordered the trumpets to be brought from the ship, and he in turn danced to entertain the Hottentots. If we try to visualise a nineteenth-century British traveller dancing to entertain some naked savages in Africa we immediately realise the magnitude of the change that had taken place. Janheinz Jahn, in his fascinating anthology *Wir nannten sie Wilde* (We Called Them Savages) shows us how the prejudice grew. One hundred and fifty years after Vasco da Gama, a German traveller, Siegmund Wurffbain, stayed for three days on the Cape coast and returned with a somewhat fantastic account of the 'disgusting' customs of the Hottentots. Subsequent travellers accepted his stories and enlarged upon them. Many of these travellers were simple sailors whose main interest appears to have been to bring back a tall story. In 1659 the Swiss traveller Herport used the word 'savages' for the first time. In 1672 Jacob Saar described the Hottentots as 'almost inhuman'. In 1680 Johann Christian Hoffmann thought that the Hottentots were 'huge monkeys rather than proper human beings'.

The idea of the 'savage' and inferior native was widely accepted in Europe only during the seventeenth century, when it became a convenient theory to justify the horrors of the slave trade. If Christianity accepted these prejudices for a long time it must also be admitted that it contributed much to the abolition movement. When missionaries started serious activity in West Africa during the nineteenth century, however, a new type of prejudice had grown up in Europe. Industrialisation had rapidly widened the gap between Europe and the rest of the world. It was easy for Europeans to see themselves as a superior race, because the rate of their 'progress' and the power they wielded seemed to support such a view. The Victorians saw the evolution of culture as a kind of sequence to the evolution of species. As complex species gradually evolve from primitive ones, so complex

cultures evolve from simple ones. Man is at the top of the biological pyramid and European civilisation at the top of the cultural pyramid. In this view foreign cultures do not represent valid alternative interpretations of the world, but merely unsuccessful attempts to achieve the European ideal. Seen in this context, the early missionaries' activities were entirely legitimate. African religions did not appear to them as different views of life, but simply as bewildered, confused attempts to grope for the one truth that Christianity had to offer. The stylisations of African art appeared as the failure of the crude craftsman to represent his objects faithfully. What was there to preserve?

These ideas were so firmly implanted in European and American minds that they were retained in spite of contrary evidence. The American Baptist missionary Bowen reports as early as 1857 his own astonishment when a priest of Shango, the thunder god, told him: 'You cannot see Shango any more than you can see your own god.' Yet it did not prevent his mission from regarding the Yoruba people as 'fetish worshippers'. But then anthropology is a very young science and only the last few decades have really supplied us with the knowledge we need to understand and respect African cultures. One is tempted to speculate about what would have happened if missionaries had first gone to Africa after World War I. Undoubtedly they would have been more understanding, found more in common with African religion, and been far more careful not to destroy unnecessarily.

We have lost faith in the superiority of our own culture. We seem to have lost control over the developments that drive us on and we are beginning to fear the future. We find it difficult to adjust to the rapid changes in our own culture. With growing alarm we begin to see that we are pressing the entire world into one prefabricated mould. Too late, perhaps, we begin to understand and love other people's ways of life. The empire builder has lost faith in his *mission civilisatrice*, as the French used to call it so pompously.

The Christian missionary is also more doubtful today, more conscientious. He is more careful not to interfere unnecessarily in cultural matters. In the *Constitution of Sacred Liturgy* the second Vatican Council declared that:

'. . . . the Church has no wish to impose a rigid uniformity in matters which do not implicate the faith or good of the whole community; rather does she respect the genius and talents of the various races and nations. Anything in these people's way of life which is not indissolubly bound up

with superstition and error she studies with sympathy, and, if possible, preserves intact. . . .'

This new attitude of tolerance has enabled Catholic fathers to write serious studies of Bantu philosophy, to introduce African music and drums into the church, and to use African carvers, and even traditional African styles in an attempt to evolve a new Christian art. The most famous and important of these experiments was carried out by Father Kevin Carroll in Oye Ekiti in Western Nigeria. The work is now thoroughly documented in his richly illustrated book: *Yoruba Religious Carving* (Geoffrey Chapman, London, 1967; Praeger, New York, 1967). I have criticised the artistic results of this experiment elsewhere—but the fact remains: African art has been accepted and respected by the mission. Moreover, the Church has become the most important patron of a dying craft.

The colonial administrator was less directly involved in the destructive process than the missionary. British rule in West Africa followed reluctantly in the wake of the traders. The principle of indirect rule meant that chieftaincies were respected and therefore some of the religious sanctions that upheld them had to be respected too. So far as African culture was concerned, the administrator was on the whole prepared to let sleeping dogs lie. Open conflict and the use of military power were relatively limited in West Africa, the destruction of Benin and the Ashanti war being exceptions. The administration did interfere with certain customs that were considered barbarous. In many cases, such as the suppression of human sacrifice, these were obvious measures and they probably did not interfere radically with African traditions.

On other occasions, however, government interference was more destructive, when it acted on bad advice or from ignorance. In Nigeria the banning of the Sonponna cult was a spectacular case. The priests were accused of wilfully spreading smallpox in the community in order to inherit the possessions of those who were killed by the smallpox god. There is evidence today from the investigations of anthropologists that the cult was completely misinterpreted by the administration.

The destructive way in which government interference can work, however well intentioned, is exemplified by the following incident which happened in Oyo, Western Nigeria, in 1946. According to an ancient custom, the death of the Alafin or king had to be followed by a number of suicides by people who had to accompany the king to the next world. Particularly important was the commander of the cavalry, who celebrated the day of his death with great ceremony, dancing

6

through the town all day in his 'robe of death' until he returned home in the evening to die.

This custom should have been celebrated for the last time in 1946, but on that occasion the British district officer interfered. The commander of the cavalry was arrested in the middle of his ceremonial dance and charged with attempted suicide. He was let off lightly, but in any case the spell was broken and he remained alive. However, his son, who was trading in the Gold Coast, hurried home to bury his father when he read of the death of the king. But when he entered the house and met his father alive he was so shocked and ashamed that he killed himself on the spot.

This story is an ironic comment on the humanitarian and civilising efforts of a foreign administration. Often such efforts merely caused a total confusion of values. Once again it is easy to apportion blame, but one should remember that the administrator has little understanding of indigenous cultures (he is moved to a new station every two years to prevent him from getting too 'involved' with the local population) and that he can only act according to his own standards.

Certainly the impact made by French colonial rule was more decisive. Instead of merely 'carrying on' somewhat reluctantly, like the British, they were filled with a sense of mission based on the firm conviction that French culture was the only one worth having. They had no time for chieftaincies and respected no tradition. They imposed both forced labour and conscription. It is a surprising experience to go to some ancient shrine in a remote village in Dahomey and discover that the dignified priest is an *ancien combattant* and that he proudly wears an old army coat on Sundays.

The missionary and the administrator played an important part in undermining local values and thus contributing towards the decline of traditional art. It is important to remember, however, that trade and industrialisation were perhaps more important factors still. The example of Japan shows clearly that indigenous art forms and crafts may die out in a country where missionaries are notoriously unsuccessful and where there was no foreign rule.

In Africa the traders were the real driving force behind British government policy. First the slave trade was condoned because labour was needed on West Indian plantations. Later it was abolished because labour was then needed in West Africa to produce the palm oil that was required for growing British industries. As happened all over the world, the

7

machine product swamped local markets and drove the local craftsman out of business. Japanese enamel ware has largely replaced the carved calabashes, the Lancashire cotton mills have ousted the weaver in Africa as they did in England, and pottery has surrendered to plastic.

The administrator may be fairly willing 'to leave people alone' as long as they keep law and order. The trader cannot leave anyone alone because people in a self-contained economy do not make customers. I can remember a European tobacco company trying to persuade a small West African tribe to plant their tobacco. They offered good money. But the people did not need money. They grew their own food, built their own houses, wove their own cloth. Their religion provided all the answers to the riddles of life. What could they do with money?

The administrator can leave people to their own devices as long as they are peaceful. The trader wants to 'open up' the country. He must create 'new needs' which can be satisfied only with money before the people will plant his tobacco. The colonial government usually gives way to such pressures. After all, the British fought a famous war (with the French as allies) to force the Chinese to legalise the British opium trade in their country. The missionary may become an unwilling tool in this vicious circle of events. For it is he who opens the school that creates not only Christian converts, but also a young generation with new needs—customers of imported goods. Thus in the colonial situation the missionary can become the unwilling torchbearer of material civilisation or even of colonial rule.

The Cameroonian novelist Mongo Beti has drawn a bitter and ironic picture of this interdependence in his novel *Le Pauvre Christ de Bomba*. In the book, the Catholic Father Drumont is worried about his lack of success with a remote forest tribe. But the cynical *commandant* Monsieur Vidal offers a solution. He is going to build a road through the area. When the forced labour recruitment begins, he will exempt those who will allow themselves to be baptised. In this way Father Drumont's church will soon be filled. The Father is outraged but Monsieur Vidal points out: 'After all we are both in the same boat.'

The Father begins to understand the interdependence between Church and Government in a colonial set-up and decides to resign. To explain his decision to his congregation he tells the following parable: 'The notorious Saba people are reputed to always travel in twos. One arrives at a place about

a day before the other and he strews bad medicine all about. Everyone falls sick, but soon the second arrives and he carries the antidote in his bag and cures everyone and thus becomes rich.' This is, of course, a gross exaggeration but Mongo Beti does make the point that the small African tribes and cultures were assaulted all at once by this powerful triumvirate of foreign forces, each seeking its own ends but each inadvertently strengthening the others.

It is very tempting to see European colonialism in Africa as an invasion of mankind's last paradise, as a brutal destruction of an idyllic way of life. In fact, however, many African cultures were corrupted and depopulated by their participation in the slave trade, and many of the old African empires were already degenerate and breaking asunder when the colonial powers appeared on the scene. A confusion of tribal wars made it relatively easy for the invaders to establish gradual control through a system of treaties.

Old Oyo, the ancient capital of the Yoruba, had been unable to control its vast slave population. Rebellious slaves had established themselves in the rival city of Ilorin and with the help of Northern Muslims had invaded and destroyed the capital. In Dahomey the religious rite of human sacrifice had degenerated into bloodthirsty orgies. In the kingdom of Benin the old tradition of brass casting had already reached a state of sad decline.

Thus the collapse of African cultures was not only due to the superior military force of the European powers but also to their own state of decline and corruption. Similarly, the break-up of the African way of life was not merely precipitated by the new ideas introduced by Christian and Muslim missionaries but by inherent weaknesses in these cultures themselves. Most African religions had evolved in relative isolation. Many concepts and ideas were therefore accepted so absolutely and unquestionably that the very *presence* of other ideas, the very *possibility* of new ways of life constituted the most serious challenge.

In the Yoruba language the word *Igbabo*—meaning a believer—is synonymous with Christian. For it is inconceivable in Yoruba religion to say: I believe in Obatala the creator, or Shango the thunder god. Such a statement would already imply the *possibility* of doubt. The question, Does God exist?, simply does not arise in this culture. I remember an old priest of Obatala in Ilobu (he was reputed to be over a hundred years old) being confronted by an unruly school child from his own family. 'Your Obatala does not exist', the child

challenged him, excited by the new ideas he had been taught in school. But the old man simply smiled. 'What do you mean he does not exist? Only the thing for which we have no name does not exist.'

The complete sense of security that this statement implies makes for a tolerant religion, a religion of many gods to suit many people, a religion that allows as many approaches to the divine power as there are individuals. It is not a militant religion. It is entirely unprepared to meet those who believe they hold the one and only truth. The natural instinct is to admit Allah and Jehovah as new gods—though perhaps wicked ones—into their pantheon. To the concept of revealed truth there is simply no answer in a religion in which the relationship to one's god has to be re-established every day through divination, ritual and sacrifice.

Thus in many of these cultures all values are challenged suddenly and simultaneously. What is it that finally tempts them away to new forms of life when the old ones have been challenged? Part of the answer was supplied by a Yoruba school teacher, recently a convert to Islam, who declared that 'Islam is more comfortable'. What he meant, I think, was that in Islam and Christianity God's power and good will towards mankind are assured and we benefit from them by a simple act of obedience and belief. In the so-called pagan religion the god has to be wooed constantly, any false step may destroy the balance with disastrous effects, and the sense of responsibility on the part of those who manipulate the relationships between men and gods is overwhelming.

But apart from these new beliefs, it was above all, I think, the material benefits of the foreign culture that proved the great attraction. One must try to imagine the delight people take in a vast variety of aniline dyes, suddenly available to them cheaply on the market, when for centuries indigo has been the only colour at their disposal and even this could only be obtained by a very laborious process.

In every way these new materials offered new possibilities. Cement provided the possibility of building 'upstair' houses. New crops like cocoa represented sudden income and the possibility of acquiring and manipulating all these foreign goods. The school—with Christianity thrown in—also brought new jobs, money, power, new forms of enjoyment. On the whole, the African exchanged his severe tradition for a sense of 'Highlife', for an indulgence in the unlimited possibilities that the culture contact offered.

The impact of European civilisation on the various cultures

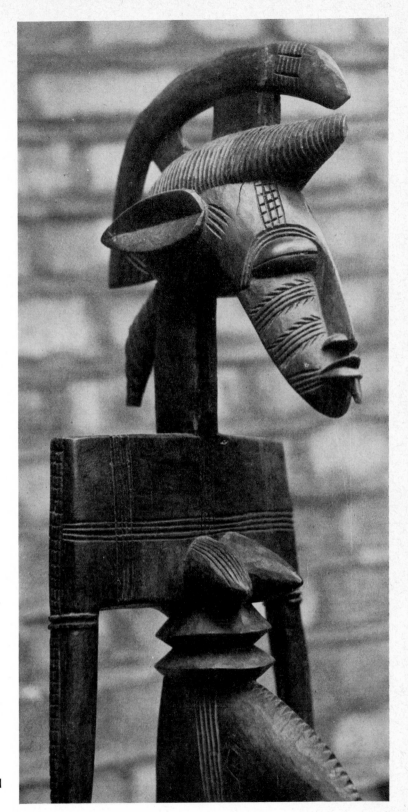

1 Senufo carving
(Ivory Coast). 36 in. Though produced for the tourist market in 1967, it is a fine work. It is much more abstract than some traditional sculpture.

of the world has been different. Some, like the Aztecs, died
fighting. Others, like the Bushmen, avoided the confrontation,
moved deeper into the desert and prefer to die a natural death.
Most African cultures have been open to the new ways of life,
have adopted, accepted, tried out. Only the purist will in-
terpret this as weakness. Naturally enough, the traditional
arts of Africa died away quickly. The creative artist, like a
sensitive barometer of society, gave the first indication of what
was happening. While some African chieftaincies were still
wielding considerable power, and some religious practices
were still widely popular, the artists were already abandoning
the tradition. To the purist lover of African art, the situation
of cultural change presented a sad picture. Everywhere the
traditional carvers either became carpenters, or banded
together in co-operatives in order to provide tourist art. This
'airport art', as it was labelled by Frank McEwen, is indeed
hideous because it is carried out without conviction or care
and simply repeats the empty forms of tradition. In many
areas the carvers have become completely cynical and
specialise in forging antiquities.

But even there the picture is not as hopeless as people some-
times try to make out. The Senufo carving on page 11 is a
piece of tourist art. It was created outside the religious con-
text for sale to a European tourist. It could hardly be mistaken
for a traditional piece. Yet it is no empty imitation. It is a fine
piece of sculpture, rather more abstract and geometrical than
Senufo art usually is.

The tourist carvings produced by co-operatives of Ibibio
carvers in Eastern Nigeria are a similar phenomenon. There the
severity of traditional masks has been replaced by light-
hearted humour and caricature, and their toylike animals com-
pare with the best of European folk art. Another extraordinary
phenomenon of tourist art has recently been described by A.
Stout (*Modern Makonde Sculpture, 1967*). Here a group of
carvers who migrated from Mozambique to Tanzania work
entirely for tourist shops, yet refuse to serialise their work like
the true airport artist. Instead they have created a new market
for themselves in bizarre, exotic, 'witchcraft' carvings, many
of dubious artistic quality, but certainly not stereotyped.
Many collectors and writers on African art seem to mistake
conventional orthodoxy for quality. In spite of the general
decline, some interesting work is still being produced in this
unlikely context.

For those who have had their eyes open, it has been clear
that new forms and new functions of art have been emerging

2 Leopard
from Ikot-Epene, Eastern
Nigeria. 14 in. Produced for
tourist market by a carvers'
co-operative.

everywhere. The spirit of optimism and the sense of Highlife
that preceded independence throughout West Africa created
numerous exuberant art forms: cement lions on Yoruba
houses, popular shop signs in Ibo cities, paintings on lorries
and in bars, cement sculpture on tombs, new styles in dress,
batiks, embroidery, etc. A bright colourful popular art sprang
up everywhere as a visible proof that African creativity was
very much alive, that only a shift of emphasis had taken place.
These popular forms heralded the coming of the intellectual
African artist. The significant breakthrough has been fairly
recent. Janheinz Jahn, as recently as 1958, was forced to say in
Muntu: 'Independent artists are still rare in Africa. . . .' Jahn
was trying to define the character of 'Neo-African' art, as a
kind of counterpart to the literature of *Négritude*. But he could
only find two examples to illustrate his case: an unconvincing
carving by Félix Idubor and a lesser painting by Ben En-
wonwu. He was forced to stretch his point by stating that
'various European artists are closer to the African attitude to
art than are many artists in Africa'. And he then went on to

analyse some works by Klee, Picasso, Wilfredo Lam and Susanne Wenger. If he were to rewrite his book today—not quite a decade later—he would have plenty of material to draw on.

A more optimistic picture of the Afro-European culture contact is emerging today. It is no longer possible to look at African art and see nothing but a continuous and rapid process of disintegration. We can now see that African art has responded to the social and political upheavals that have taken place all over the continent. The African artist has refused to be fossilised. New types of artists give expression to new ideas, work for different clients, fulfil new functions. Accepting the challenge of Europe, the African artist does not hesitate to adopt new materials, be inspired by foreign art, look for a different role in society. New forms, new styles and new personalities are emerging everywhere and this contemporary African art is rapidly becoming as rich and as varied as were the more rigid artistic conventions of several generations ago.

1 Between two worlds

On the whole it can be said that the modern African artists who gave expression to the new ideas and the new life that were sweeping across Africa were not the sons of traditional carvers or brass casters. They came from quite different families and often from quite surprising backgrounds. However, there were a few traditional artists who somehow got a foothold in the modern world and overcame the twin dangers of becoming tourist artists or of stopping work altogether.

Three of these artists will be discussed in this chapter. They are unique in that they do not really represent the beginning of a new movement nor are they merely examples of the gradual petering out of great traditions. They are traditional artists who, through unusual strength of personality and fortunate circumstances, have been able to reach out beyond the world in which they grew up, have succeeded in working for a wider, largely European audience without becoming cheap, and in their work have given expression to the world of transition in which they live.

Yemi Bisiri is a traditional Yoruba brass caster. He comes from a long line of artist craftsmen working in the same tradition. In Yoruba culture brass was a sacred metal and its use was restricted to certain cult groups, the most important being the secret Ogboni Society. This is a religious association of old men, primarily devoted to the worship of the earth, and therefore also concerned with certain aspects of law and justice in the community, for some offences, like murder, are offences against *Ile*, the earth. Until recent constitutional developments supplanted them, the Ogboni also wielded considerable political power and formed a kind of counter-balance to the power of the king and the military chiefs. While deprived of their official political and judicial functions, the Ogboni still continue as a religious society and wield considerable influence in some parts of the country.

Each member of this society must have two little brass figures, male and female, which are both insignia of office and ritual objects. Yemi Bisiri is one of the last three or four brass casters who still produce such work in Nigeria today.

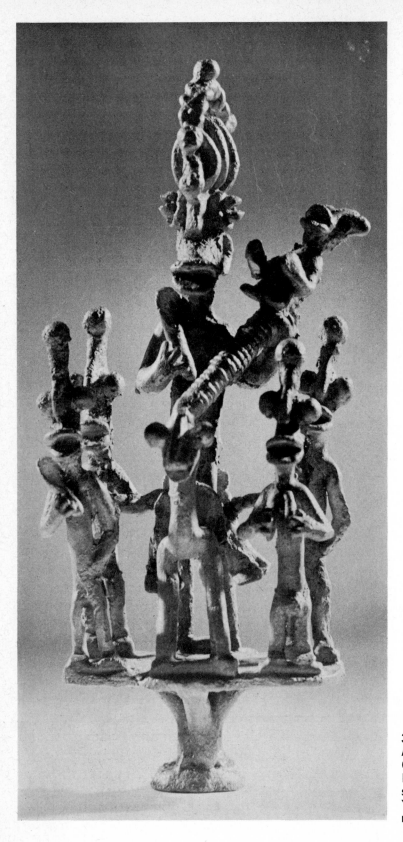

3 Yemi Bisiri
Horseman (Ilobu, near
Oshogbo, Nigeria). 11½ in.
Brass figure made for the
secret Ogboni Society, a
Yoruba earth cult. *Cire perdu*
method.

4 Yemi Bisiri
Mother and Children (Ilobu,
near Oshogbo). 11 in. Brass
figure made for the secret
Ogboni Society, a Yoruba
earth cult. *Cire perdu*
method.

The relatively high quality of the work of the casters contrasts with the utter decline of woodcarving in the same region. This may be so because traditional religion now has so little prestige that few people, even if they had the money, would want to make themselves conspicuous by ordering religious carvings for the family shrine. The Ogboni Society, on the other hand, still enjoys some prestige because of its political influence and the secrecy attached to its activities ensures that the ritual brass objects are never shown to non-members.

Bisiri's art, then, is firmly embedded in tradition. He uses the same *cire perdue* method, and works for the same religious society as his father did. His subject matter is basically as limited as that of his forefathers: a male figure on horseback, and the female one surrounded by many children—these are the themes he has to repeat in endless variations. Yet his style is distinct. He is not merely reproducing weaker copies of his father's work. He has the courage to be different and his work is bold and confident.

Yemi Bisiri is of course a different person from his predecessors. He did not go to school, but he could not fail to witness the social revolution going on around him. He is the first of his line to have voted in a political election and to have been a member of a party, the first to question the authority of the king, the first to work for an Ogboni Society that wields little real power. No brass caster before him owned a radio set, he is the first to travel to Lagos and Ibadan and see the bright new life in the cities. Even his own little village has changed: baroque cement houses in the 'Brazilian style'* have replaced many of the old mud huts; there are bars, where school teachers and clerks drink beer instead of palm wine. Yemi Bisiri, even in his village off the beaten track, must have been caught in the whirl of optimism and euphoria that seized the country just before independence.

How could he work in the same severe style, the classical restraint of his forefathers? The hard perfection, the sinister expression of the traditional 'Edan' image could hardly suit his mood, because the formative years of his artistic career were the forties and fifties. Bisiri's work is less severe, more colourful, extravagantly top-heavy with ornament. He is particularly sensitive to his materials. He does not hide the processes of rolling, kneading and pressing his wax models.

*Liberated Yoruba slaves began to return from Brazil in the 1830s. Some of the houses they built in a Portuguese baroque style can still be seen in Lagos. Up-country, colourful imitations of these were often created in mud.

One can feel the movement of his hand in every little ornament and he never files the finished product, but leaves the rough grainy surface of casting exposed.

The basic forms he uses are incredibly simplified. In his smaller figures a single, long cylindrical shape can serve as body, neck and face, and this will be capped by one single curved shape to represent nose and skull. On larger figures the line beginning with the nose may sweep boldly upwards to become the crown. This astonishingly simple basic shape is then animated by a heavy load of ornament and detail which is stuck on to the structural form: eyes are large bulging spheres stuck on both sides of the head, coils surrounding the body represent clothes. With a wealth of such detail—protruding lips, dangling ear-rings, coiled horse reins, spiral crowns, pendulous breasts, curved arms and legs and bulging eyes—the artist hides the basic shapes of his figure and creates a kind of broken façade like a baroque building. There is energetic movement and exalted vitality in these figures, as never before seen in Yoruba art.

Yemi Bisiri is truly a phenomenon in African art today. He works in a tradition, and produces only a few standard patterns to serve the ritual purposes of an old cult group that is slowly dying. He is the first of his line whose work is occasionally also produced for European collectors. His work shows an individual style, a personal touch that set him apart from the long line of brass casters from which he has sprung. Never repetitive, never stereotyped, he succeeds in conveying the spirit of his own time within the limits of his very restricted function as a Yoruba brass caster. In a sense, he could be called the first modern Yoruba artist.

Ovia Idah, the Benin wood carver, belongs to roughly the same generation. He grew up in the palace of Oba Eweka, who was himself interested in carving and who taught Idah to carve wood, ivory, calabashes, palm nuts and coconuts in the traditional manner. Idah was brought up in a completely traditional way; he joined one of the palace societies and never went to school. When he grew up he found that his profession as a carver did not feed him very well. Benin was then a backwater town in Nigeria. The king had lost considerably in status after the long enforced exile of his predecessor, and with his greatly reduced court and means he could no longer be the great patron of the arts which his predecessors had been. The tourists had not yet discovered Benin.

So Idah decided to try for better luck in the big city. He went to Lagos, the federal capital, and he became a carpenter

in the Public Works Department. For a decade he worked contentedly in Lagos, and only occasionally would he make a carving, more for his own entertainment than for sale. Then one day he was discovered by Mr. K. C. Murray, the then director of antiquities, who was fascinated by Idah's talent and who arranged for him to become a craft teacher in King's College, the best-known secondary school in Lagos. Idah spent twenty-seven years in Lagos, and only a severe illness finally brought him home. When he recovered after many months, the new Oba Akenzua would not allow him to leave again because he wanted to encourage the arts in Benin, and Idah, somewhat reluctantly, stayed. He was put in charge of the Benin co-operative of carvers, where semi-traditional work is being turned out somewhat mechanically for tourist consumption.

The story of Idah so far is quite typical of hundreds of traditional artists and craftsmen. Many well-meaning administrators have tried, in different parts of Africa, to preserve the dying arts by employing traditional artists to teach in schools. The results have always been disastrous. The young African boy who had fought his way into primary or even secondary school against overwhelming odds hopes to find there the key to a new life, and has little interest in the old crafts of his country. Moreover, the work of even great artists quickly disintegrates in such an environment. One such experiment was described by Mr. J. D. Clerke in a fascinating booklet called *An Experiment in Education*. Clerke, an education officer in Nigeria, arranged for a truly great carver, Gbamboye, to teach in a school in Omu Aran in Northern Nigeria. But in the new surroundings Gbamboye's work soon lost its power and bite.

In Lagos the same fate seemed imminent for Idah. The work he produced there while teaching in school was competent but indifferent. And even his return to Benin did not change this at once. He continued to carve panels and trays and heads in the traditional manner, selling his work to the king or to occasional visitors, but there was little to distinguish his work from the rest of the carvers guild except for a certain technical precision.

What was unusual about Idah was not so much his work, but his personality. Idah was a man always ready to pick up a new idea or try something new, defiantly ready to defend his personal tastes and whimsical idiosyncrasies. When he returned home from Lagos his strange behaviour must have upset everybody. The carvers were upset because he started

5 Ovia Idah
(Benin). *Terracotta*, 10 in.,
representing a sacrifice.

to work in strange materials: ebony and cement. The king
and the chiefs were upset because he insisted on building his
house on a remnant of the old city wall. The whole population
of Benin was upset because of the strange house Idah in-
sisted on putting up. There was none of the archaic dignity
of traditional Benin architecture—no polished fluted mud
walls, no impluvium courtyards, leading into other courtyards
in an endless maze-like succession. On the other hand, this
was not a 'respectable' modern building either. No glass
louvres, no civil service 'parlour' complete with curtains and
heavily upholstered public works furniture.

Idah is a great individualist. He is a kind of Nigerian Gaudi,
and was probably the first 'crank' Benin had ever seen. His
little home towers over the city wall. The visitor approaches
it through an attractive garden. Walking past a life-size
statue of Idah himself, one comes to a steep flight of steps.
Faces in cement stare up at one from the steps and as one
reaches the top one finds the entrance of the house flanked by

6 Ovia Idah
Detail of Plate 5.

bizarre cement figures: an elephant trampling on a man, Queen Elizabeth shaking hands with the King of Benin. As the visitor enters the door he faces his own image in a circular room, for exactly opposite the door is a man-size mirror. As one explores the house further, one is led from one delight to another: every room is on a different floor level, short steps and a narrow corridor connect one to the other. Somewhere there is a tiny room in which Idah keeps his personal museum of antiquities. There is a sitting room, which is as 'left bank' as any artist's studio one expects to find in Paris. For here Idah ingenuously mixes his own varied artistic production with *objets trouvés*, odd bits of metal, broken-up candelabra, china pots acquired at the auction of a retired district officer's effects, old bits of Benin craftsmanship, and cast iron chairs bought from Nigeria's oldest cinema (1907!). Over the pillow of his bed, Idah has painted his own head. There is no room to equal this in Nigeria, no surrealist contraption in Europe that has as powerful an impact.

Idah worked at a time when reorientation was almost impossible for the traditional artist. But his spirit was undaunted. While all his colleagues cashed in handsomely on the tourist trade and built themselves comfortable bourgeois mansions, Idah insisted on living apart, and like a modern European artist was only too conscious that he was an outsider. Like a modern European artist he was intrigued by new techniques, new types of commissions. He experimented all the time. He was the first to carve in ebony, the first to make

cement sculpture. When the King of Benin founded a new Christian sect and built the church of the Holy Arosa, it was Idah who cast a new kind of large cement brick that had a relief pattern on it. It is worth remembering that Idah found his personality—the personality of a modern artist in the cultural vacuum of Benin—long before he was discovered by intellectual Europeans, with whom he instinctively felt at home, much more so than with his actual compatriots.

Writing about Idah in 1960 I felt obliged to say that it was his personality that had achieved greatness. That he had found a new 'modern' concept of the artist and his revolutionary, stubbornly experimental function in society, but that he had not been able to liberate his work entirely from the shackles of the deadly Benin convention. All Bini artists labour under this disability today. They come from one of the greatest art centres in Africa, but one that degenerated as long ago as the eighteenth century and that has been vegetating in a climate of fossilised, rigid conventionalism.

Yet complete liberation was achieved by Idah when he turned—in his seventies—to terracotta work. Here he suddenly found a medium which was sufficiently removed from conventional Benin carving to allow him complete freedom of invention, and he knew that his client (the author) was no great admirer of the Benin tradition. Out of a series of terracotta reliefs which Idah created at this late age, two could be considered his masterworks. They are now in the collection of the University of Ibadan. Both represent scenes of ritual sacrifice: one of a cow, the other of a human being.

Both panels are crowded scenes, Breughelesque nightmares. The composition is very lively and fluid and there is a feeling of exalted excitement such as was never known in the sedate dignified art of the royal court of Benin. These reliefs are certainly technically inferior to the classical brass plaques of sixteenth century Benin. But they are more expressive, more emotional, more human.

Idah is a lonely individual who under the most unfavourable circumstances has been able to preserve his romanticism and his warm human involvement. Like many of his colleagues in modern Europe he has warded off the pressures of social and artistic convention by seeking refuge in his own eccentricity. Late in life he has created a few works of great individuality and originality whose appeal reaches out far beyond the comprehension of the community he is working in. Idah comes from a background similar to that of Yemi Bisiri,

but the breakthrough he achieved was in many ways much more complete than that of his Yoruba colleague.

Lamidi Fakeye is a much younger man than Bisiri and Idah. Like them, he is the descendant of a long line of craftsmen, but unlike them he had a primary education and was exposed to far more Western influences. He grew up a Muslim, but later joined the workshop of the Catholic Mission in Oye Ekiti (Western Nigeria) and spent his formative years with them, executing commissions for churches. A Muslim carver, trained in a pagan tradition and working for the Catholic Church: could one imagine a greater contradiction in terms? What kind of *salto mortale* of the soul is necessary to make this possible? But in Nigeria this *is* possible and one need not have a split personality to do it.

Father Kevin Carroll, who ran the workshop in Oye Ekiti and who inspired so much Christian art in Nigeria, believes

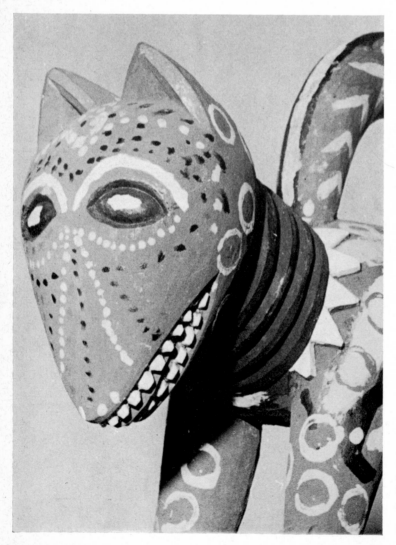

7 Lamidi Fakeye
Leopard, superstructure of a mask (Nigeria). Painted in commercial colours. This mask was not made for a religious society, but for a British Council exhibition in Ibadan.

8 Lamidi Fakeye
Mask, face in traditional Ekiti style. This pot mask is put over the dancer's head, and he looks out through the mouth. Produced for an exhibition in Ibadan, not for a religious society.

that traditional art in Yorubaland was not really inspired by pagan religion. He says that it was an illustrative art, and that it made little difference to the carver whether he illustrated pagan or Christian stories. In fact, Christian mythology should have been more readily accessible to Lamidi Fakeye because he was a Muslim, since the Koran treats Jesus and Mary with the greatest reverence. I tend to disagree on this point. Traditional art *was* religious, but Yoruba religion is tolerant and inclined towards syncretism with other religions.

Yoruba slaves taken to the new world created a complete fusion between their own gods, the *orisha*, and Catholic saints, and to a lesser extent this has happened in Nigeria too. Lamidi Fakeye accomplishes his extraordinary feat because he is not an *orthodox* Muslim, and because he has complete tolerance of his father, who is a pagan, and his brother, who is a Christian. Were he a good Muslim, he would not carve at all; and I suspect that his Christian friend George Bandele, who is also carving for the Church, is only carving because he is not a

25

very orthodox Christian. If he were, he would probably wish to dissociate himself from the pagan 'idol'-making business.

Like many Yoruba people, Fakeye has accepted the diversity of cultures and religions within his own community. He serves one god, but respects the others. Without being an intellectual he has taken up the position of the modern artist who does not merely work within a closed cultural circuit, as his father did, but who accepts commissions from wherever they come and who tries to understand the client's ideas and practical needs. Fakeye has worked for orisha shrines, Yoruba palaces, Catholic churches, the University of Ibadan, the Western House of Assembly, and innumerable European and American art collectors and tourists.

9 Lamidi Fakeye
Christ Carrying the Cross
(Nigeria). Carved for the
Roman Catholic Church
in Ire, Ekiti.

Without any doubt, it was the unexpected interest and patronage of the Catholic Church that made him stick to his trade and gave him the encouragement he needed in order to make a place for himself as a carver in the modern world. Without the Oye Ekiti workshop he would have drifted away into some other profession like so many of his contemporaries, without ever discovering the openings that were developing for the traditional craftsman.

Unfortunately, Lamidi has been a little too successful. He left the Mission to work for private patrons. He went to France on a Government scholarship. He is now established in Ibadan with a host of apprentices and turns out what Father Carroll has described as 'parlour pieces'. The work is becoming increasingly dull and repetitive. The fault lies largely in the commercialisation of his art but he had already set out on the wrong road while working for the Catholic Mission. The Church and his secular clients put too much emphasis on orthodox Yoruba style. Everyone wanted Fakeye to be a 'genuine' Yoruba artist, treating new subjects and new ideas in the hallowed style of his forefathers. This is not possible. No young man in his early thirties can feel the same about life as his father. For him to try to express himself in the same severe stylisations must, ultimately, be hypocritical. Fakeye has occasionally made tentative moves towards a brighter, more playful type of carving. The lighthearted charm of the brightly painted leopard (see page 24) convinces me more than the tight rigidity of the pseudo-traditional forms on some of his church doors. In the doors, competent slickness replaces the intensity and vivid composition of his father's work and the warm playfulness of some of his other work has given way to empty, fossilised traditional forms.

I do not think that Lamidi Fakeye has quite made the transition from the traditional carver to the modern artist. He has certainly battled against overwhelming odds, and if he has not become a great artist he has remained a fine craftsman when the tradition was threatened with complete extinction. As a personality he stands besides Bisiri and Idah as one who has weathered the storm and has gained a foothold in both worlds.

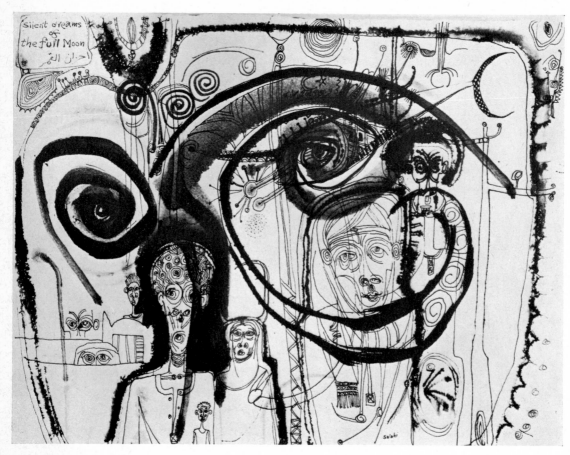

10 Ibrahim Salahi
*Silent Dreams of the Full
Moon* (Khartoum), 1962.
Pen and ink.

2 Without a tradition . . .

Islam does not allow figurative representation and consequently Islamic art has always been restricted to geometric ornament and calligraphy. In spite of this limitation Khartoum has become one of the most important centres of modern art in Africa. No place could look less suitable for this role to the visitor. The city bestrides the confluence of the two Niles and straggles out into the desert that surrounds it. The modern area of the town is small. There is no art gallery there to exhibit and give encouragement, and indigenous artists have not been used by the architects who planned the large government buildings.

The art department of the Khartoum Technical Institute is a kind of oasis in this desert. A group of serious and highly sophisticated artists is at work there. Although they have been able to form an artists association which manages to put on annual exhibitions (often in an hotel lounge) the reputations and fortunes of these artists are still being made in the galleries of Europe.

The most remarkable artist in this group is **Ibrahim El Salahi**. Salahi was trained at the Slade School in London and then returned to teach at the Khartoum Technical Institute. As he came to the Slade with no tradition of his own to fall back on, it was only natural for him to emerge a typical product of that school. Competent portraits, pleasing landscapes —all very attractive and technically professional. But returning to his home town he felt dissatisfied, found his work meaningless in that setting. He loved Khartoum and the desert that surrounded it and wanted to feel part of it. But there was little stimulus he could receive locally, there was no tradition of wood carving or mural design. Salahi retired into himself. In those first years he spent much time in the desert meditating. His love of the Koran led him to start practising Arabic calligraphy. The writing of Koranic verses had a soothing effect on him, he loved the swinging rhythms of the letters and gradually began to see them as forms and images rather than as texts. His dreamlike vision began to impose itself on the writing and the letters began to sprout decorative

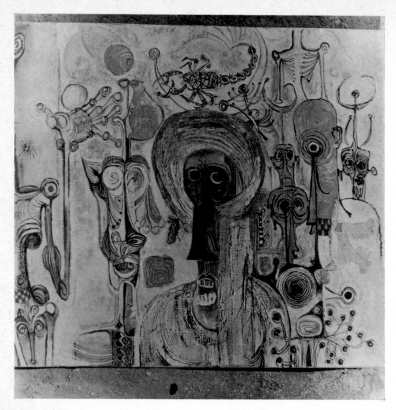

11 Salahi
Death of a Child (Khartoum).
Oil.

doodles, which in turn became more and more like figurative images.

When the rhythm of calligraphy had liberated itself from the letter, Salahi had found his style. He had found the sensitive, nervous line that seems to feel its way around the image, like the delicate antennae of an insect. Sometimes he gives both structure and texture to his pictures by the use of patterned surfaces, patterns that might be derived from the popular coloured basket-weaving in the Sudan, but which swing and breathe like a living skin. The intricate elegance of Salahi's shapes never becomes rigidly *formal*, always remains tender and expressive. The light touch of his brush contrasts strangely with the haunting, severe images that form the content of his pictures.

There are creatures there, half animal, half human. Mask-like faces, human beings transfigured through suffering, turned to gods or spirits. There are eyes looking not at us but through us; the mystery of African ritual seems combined with the otherworldliness of icons, with the introverted dreaming of the Muslim saint in the desert. No artist could create a more perfect synthesis of the cultural elements that make up the modern Sudan, the Islamic tradition and the wider all-African orientation of today. Yet Salahi is not a

30

12 Salahi
Revolution (Khartoum). Oil.

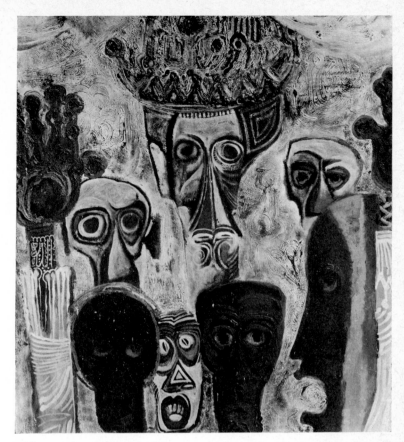

self-consciously 'African' artist, he is no preacher of *Négritude*, he is no preacher of anything; he is a dreamer.

To understand Salahi's mind and his approach to his art, it is best to hear him talk about his own pictures. The following interpretations were given by him to the magazine *Black Orpheus*. They read like poems rather than analyses:

A man lost in his introspective visions
Looking in and into himself
Sitting in the shade of a cracked mud wall
Gazing as the shadows creep over his toes
Staring into the blaze of the sun
Gazing into nothingness.
Until his two eyes become one,
Gazing into the empty horizon of far-away dreams,
Into a mirror that I hold before my hands,
To paint a portrait for me.

In my dreams I used to see a donkey standing
in the sun. Standing still and thinking. A donkey
with a long drooping face and sad vague eyes.
The donkey's face becomes mine. My face becomes

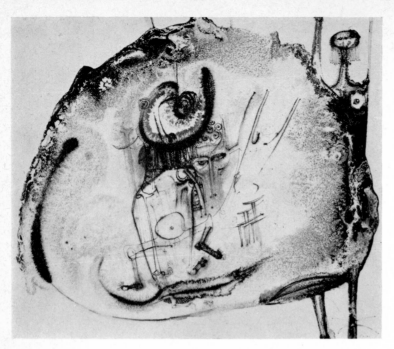

13 Salahi
(Khartoum), 1964. Pen and
ink drawing.

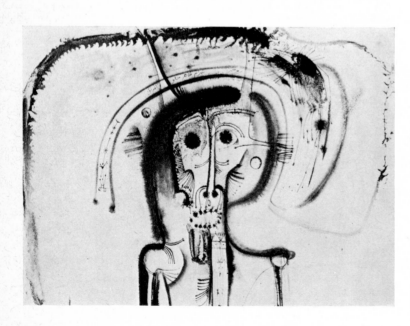

14 Salahi
(Khartoum), 1964. Pen and
ink drawing.

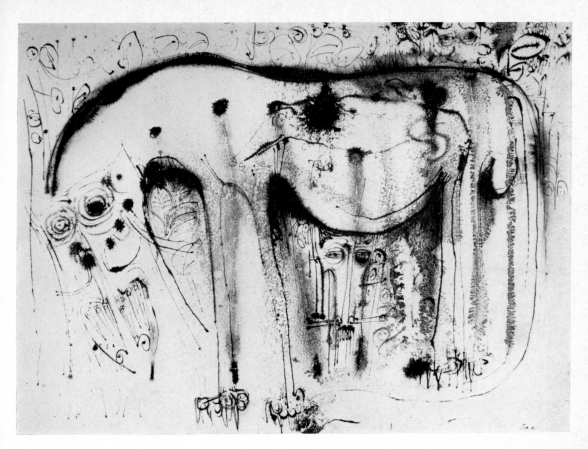

15 Salahi
(Khartoum), 1964. Pen and
ink drawing.

long and I stand in the sun thinking in place of
that donkey.

One Ramadan a scorpion stung my little nephew.
We just stood there. One can do nothing. Doctors
were useless. Two hours and he dies. His mother
did not cry. I wished she could have wept and piled
earth over her head. She saw her child die. Before
her eyes. Foams of blood bubbled out of his lips.
Black poison. He dies. We took him home cold and
silent. We buried him. He came back. I saw him three
days later at dawn.

Empty eyes of unmarried girls always
looking into empty space. Waiting.
These eyes haunt me. I wish they could
marry and smile.

Calligraphy sparked off Salahi's creative activity and the forms of the Arabic alphabet are still the basis of all his images. However, a colleague of his at the Khartoum Technical Institute, **Ahmed Shibrain,** has found full expression in the ancient art of calligraphy itself, which he treats in an original and modern way. Arabic calligraphy grew out of the profound respect for the sacred word of the Koran and for the Arabic language as such. The purpose of the decorative bits of writing that have adorned Sudanese houses for centuries was not only to convey the message of the text and to pay homage to the sacred language, but also to serve as ornaments and pictures in their own right.

It is this latter function that allows Shibrain to treat his texts with the utmost freedom, to the point of illegibility. He is still inspired by the message of the text, but he abstracts and simplifies its visual representation to the point where we begin to think of European abstract artists like Soulages and Hartung. However, Shibrain's forms do not swim in a vacuum, they do not suffer from the emptiness and flimsiness, the contrived, rational coldness of so much abstract art in Europe. Shibrain's calligraphy is inspired, highly sensitive and capable of expressing a wide variety of moods. An ancient, somewhat rigid tradition was turned by Shibrain into a vehicle for modern art—a rare achievement in contemporary African art.

Salahi's problem was, as we have seen, the lack of imagery in his tradition. There was no folk art he could have developed, no ancient iconography, no ready-made pictorial language at his disposal. Salahi had to dream up his personal world of mythology and imagery.

His Ethiopian friend **Skunder Boghossian** is in the opposite predicament. He comes from a culture where tradition is old, powerful and fossilised. Ethiopia has a tradition of wall painting in churches and of illuminating manuscripts going back to the eighth century. The conventions of this religious art are extremely rigid. Its peak period passed long ago and today the monks who continue to practise it have been caught in the process of repeating empty formulas. Many of them work for the tourist trade. Out of this activity a new popular art has developed which has changed the medium and the theme, but not the style. The present-day visitor to Addis Ababa will be accosted by young men with scrolls of canvas under their arms. They paint the battle of Adoua, hunting scenes, or the old Biblical subjects like Solomon and Sheba. They use commercial oil colours on canvas, rather than

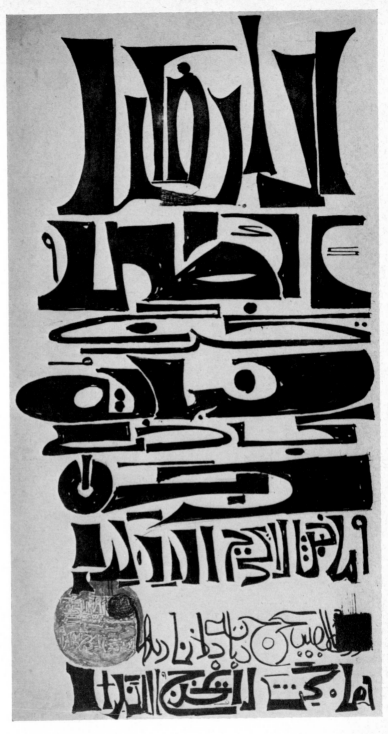

16 Ahmed Shibrain
Calligraphy (Sudan).

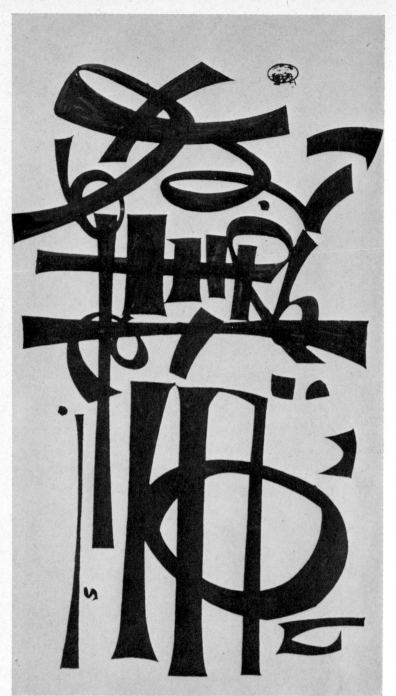

17 Shibrain
Calligraphy (Sudan). Based
on actual *suras* of the Koran,
these calligraphic designs
are handled so freely that
they are barely legible and
become abstract
compositions.

tempera on parchment, but the formula has not changed. The same little doll-like figures, staring dramatically out of the corners of their eyes. The same clear outline, the same stiff movement like figures on a merry-go-round. It is like art moving around in circles, like an art that cannot break out of its own narrow framework, long after this frame has become meaningless.

For some years, Skunder tried to find some kind of synthesis to make use of tradition, but to reinterpret it, to be a modern painter and yet to preserve his Ethiopian identity. But he soon realised that it was useless: what he needed was a clean break. He drew his conclusions and went to London and Paris, where he allowed himself to be absorbed by the mainstream of modern European art. Only after he had mastered all the new techniques and had become part of the experimental, controversial atmosphere of Parisian art life, had forgotten about his Ethiopian roots, could he feel free. After some years in Europe he had liberated himself from the burden of tradition and he was now more or less at the same point in his development that Salahi had reached when he returned to Khartoum: a master of his medium, but with no 'cultural heritage' to draw on and thrown back on his own resources. Like Salahi he had to create his own mythology around which he could orientate his art. Unlike Salahi, however, Skunder is not an introvert visionary. He is an intellectual painter. If Salahi dreamed his mythology, one could almost say of Skunder that he 'invented' it.

His first big breakthrough came with a series of paintings called *The Nourishers*. The general theme of these pictures was the generation of life, the creative process. He titled them *Birth*, *Primordial Effort*, *Interior Structure*, *The Life Giver*, *Fertility Goddess*, etc. The imagery of this series consists of fish-like or insect-like creatures, skeletal structures and intestinal forms. There is a slow writhing movement, a painful tension. Everything symbolises birth, growth, fertility, reincarnation. The colours are saturated, the application of paint is dense and rich.

Skunder buttresses his work with a philosophy which he calls 'Afro-Metaphysics'. Louise Acheson, introducing him in the catalogue of his Ibadan exhibition says: 'Skunder paints bursts of thought in a new spirit of surrealism. . . .' To understand his paintings it is of course not necessary to know all about his preoccupation with concepts like 'the eternal cycle' or the 'Great Mother' and the entire complex symbolism that went into the making of *The Nourishers*. It is

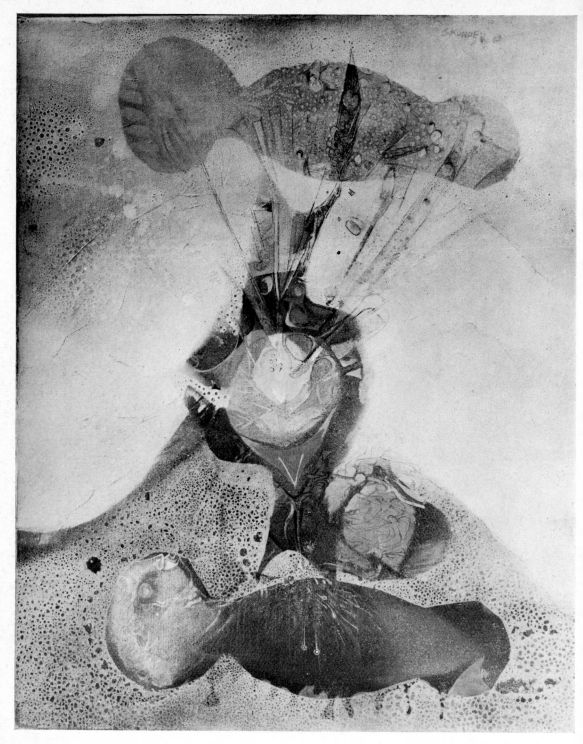

18 Skunder (Alexander Boghossian)
Explosion of the World Egg (Ethiopia), 1963. Oil.

19 Skunder (Ethiopia),
1963. Oil.

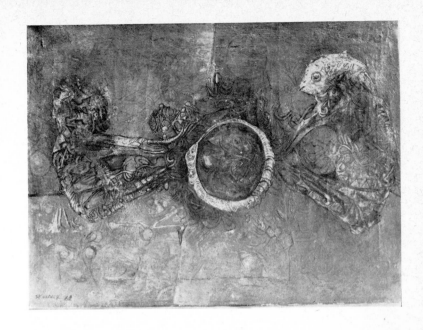

20 Skunder
Inside the World Egg
(Ethiopia), 1961. Oil.

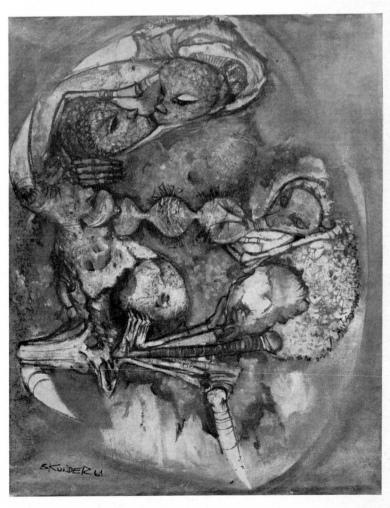

21 Kamala Ibrahim
(Sudan), 1962. Oil.
Miss Ibrahim is the first
woman painter in the Sudan,
and teaches at the
Khartoum Technical
Institute.

interesting to note, however, that Skunder derives inspiration from the great cosmologies of West Africa, from a culture that, strictly speaking, is not his own. A further point of contact here with Salahi: one comes from a Muslim Arab tradition, the other from a Semitic Christian one. Both have reached out for a wider all-African identity and seek particular inspiration in the complex cultures of West Africa. Skunder's more recent work is lighter in structure, the paint is more transparent, the composition less tight. But he is still preoccupied with similar cosmological themes: the world egg, primordial explosions, cosmic forces of creation. This sophisticated artist makes great demands on the spectator: he forces us to forget all our everyday terms of reference and to go all the way and meet him in his personal metaphysical world. It is a take-it-or-leave-it art.

3 In search of identity

An art school is, in a sense, a necessary evil. It is not really possible to teach techniques without imposing ideas on the student at the same time. The result is often a certain standardisation. Some people can tell, by looking at a student's work, which British art school he is attending. However, the student who has sufficient personality soon finds his way out of the maze when he has finished the course. After all, the school is not the only influence working on him during his training. He lives in a big city and enjoys all the stimulus its cultural life has to offer.

In a sense it is absurd: we subject the student to a process of standardisation and teach him certain techniques and even styles that are considered to be the solid basis of any artistic activity, and then we send him out into the world expecting him to forget everything as quickly as possible and to become 'original'. Somehow it seems to work. If nothing else, it is a kind of elimination process leading to the survival of the fittest.

The system becomes rather more problematical when it is applied—without any adaptation—to Africa. Can a system of training devised for another culture, and—one sometimes feels—another century, be successful when transplanted to foreign soil? While no other system exists, what else can one do? One can only begin with what one knows and hope that one will learn gradually by experience. Even if this is the case, one could hardly have discovered a less suitable place than Zaria to site the Nigerian Art School. No tradition of creative art exists in Nigeria's Muslim North. The town itself is a backwater with little cultural life, and the University is far enough away from town to prevent the students from enjoying the few events that do take place, such as the colourful Muslim festivals.

The expatriate staff find themselves many hundreds of miles from those areas of Nigeria which have an artistic tradition: from Benin, Yorubaland and the lively Ibo and Ibibio regions. It is from these areas, of course, that the art students come—for the Northerners do not take to this subject

for obvious reasons. The staff find it impossible to relate their teaching to the students' background. Even local materials are difficult to obtain. In a country that has some of the greatest wood carving traditions in the world, the art school is sited in the savannah region and the students have to work in plaster because wood is not available. Nevertheless, many of Nigeria's leading artists were trained there. Some digested the system successfully. Others became artists in spite of it.

There was a strong feeling of opposition to many of the schools, especially in the early years. Students revolted against the foreignness of it. I remember finding some students spending most of their time working secretly in their rooms and hiding the paintings from the staff. Much of what was taught was considered irrelevant and aroused in some of the students the desire to go their own way, to discover their own culture for themselves since they were taught nothing about it in the institution. Artists were born out of protest, and the search for identity became the primary motive of their artistic activity.

22 Demas Nwoko
Mother and Child (Nigeria), 1961. Oil. Orange mother on intense red background.

23 Demas Nwoko
Terracotta (Nigeria). 18½ in.
Collection: R. Wolford.

Demas Nwoko is an artist infinitely more interested in content than in technique. His paint is flat, sometimes dead and poster-like. But his pictures are acid comments on life and people, charged with a bitter kind of humour. Often his forms are consciously derived from Ibo masks; they have the

angular sharpness, the geometric pattern superimposed on anatomic structure. All his human beings are ugly, vicious and deprived of any superficial ingratiating qualities. A dignified old chief appears to be planning mischief behind his masklike weathered face. British army officers sit around, dried up and incredibly unimaginative. Adam approaches a heavy-legged Eve with a clumsy gesture; a child looks away in embarrassment while adults kiss in a bus. Nwoko's sarcasm verges on caricature at times, seldom relaxes and is sometimes

24 Demas Nwoko
Bathing Women (Nigeria), 1961.

neurotically tense. Recently Nwoko has turned to terracotta work. Clearly inspired by Nok and Ife terracottas, they are, technically, his finest work and have so far proved his most popular. The wildest praise has come from Dennis Williams who thinks that they are 'hardly inferior to the masterpieces of Ife'.

Nwoko has been an inspiring influence not only on students of the Zaria art school, but on Nigerian art as a whole. His clearly African orientation, his deliberate use of traditional forms and his uncompromising attitude have made him one of the first original artists to emerge in Nigeria. Nwoko now divides his time between painting, sculpture and the theatre. As a stage designer in the school of drama of the University of Ibadan he will be chiefly remembered for his costumes and décor for the *Palm-Wine Drinkard*, which combine both aesthetic refinement and a sense of humour.

Uche Okeke is a more introverted artist. Like Nwoko, his classmate at Zaria, Okeke was chiefly interested in finding a

25 Uche Okeke
Eze's Bird (Nigeria), 1958.
Pen and ink.

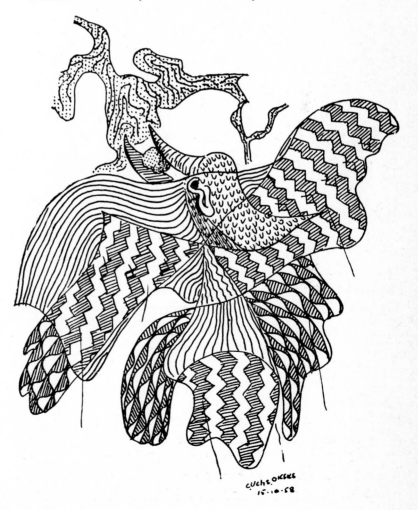

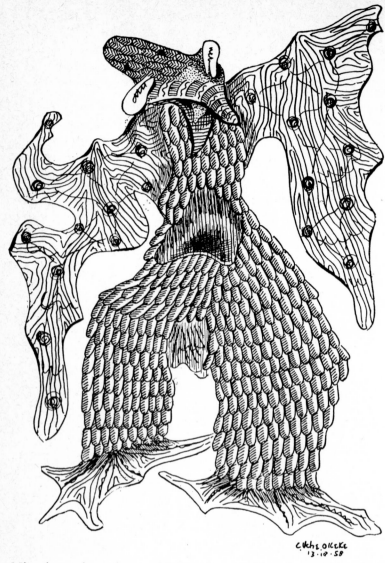

26 Uche Okeke
Beautiful Nza (Nigeria),
1958. Pen and ink.

Nigerian orientation to his art, in searching for an identity.
However he was less interested in adapting certain forms of
traditional African art. To him it was of vital importance for
the artist to study and understand the content of African art.
'I needed this to come to terms with myself.' Okeke is known
as a collector of Ibo folklore and much of his best work is
directly inspired by it. In innumerable drawings in pen and
ink Okeke leads us into a world of pure fantasy. We may not
know the story about *Nza the Smart*, or about the giant
Ojadili or about *Nkwo's Prize*. But these weird creatures are
certainly haunting. Are they plants? Are they animals?
Masks or human beings? In the fantasy world of Okeke
everything is possible. There are scaly creatures with flabby
wings, maidens whose eyes are cowrie shells, men whose hair
is feathers. Many creatures are froglike, fearsome and cold.

Others have fluid, slimy plasma forms that seem to change in front of one's eyes. But this is not a contrived world of surrealism; we feel rather that a secret door has been opened allowing us a peep into a forbidden world that has always been there, separated from us only by a thin wall. Okeke's painting explores a universe in which he is searching for balanced dignity and composition. Perhaps the long years he spent in Northern Nigeria as a child have had their effect. His well-known painting of Christ shows him detached and withdrawn and dressed like a Muslim *mallam*. Okeke spent two years in Germany studying the techniques of mosaic work and his mosaic series *The Stations of the Cross* was recently exhibited with success in Munich.

The art school of Ahmadu Bello University in Zaria has produced too many artists to be discussed in detail here, though some should at least be mentioned. Yussef Grillo is now head of the art school in Yaba (near Lagos). He is an elegant colourist whose work has been shown not only in Nigeria but also at the Piccadilly Gallery in London. Jimo Akolo, a Northern Yoruba, is one of the most technically accomplished of this group. He has great sensitivity to the quality of paint and his textures are always interesting. Bruce Onabrakpeye has specialised in graphic art and has become Nigeria's most important illustrator.

The most recent artist from Zaria is Collette Omogbai, from Benin, who has found a vigorous style of her own. Her themes are abstractions on themes of grief, agony, re-creation, curse and accident. Her manner is expressionist: simplified human forms are recognisable but are rearranged to suit the mood of the painting. Large hands and feet are used to express both movement and emotion. Bodies, heads, breasts are recomposed into large areas of colour which provide the basic structure of the picture. Her colours are intense: black, white, ultramarine, mauve, orange, are the prominent ones. The overall impression is sombre and intense. Her application of paint is always interesting, her surfaces alive.

The artists of the Zaria school represent the first decisive breakthrough in Nigerian art. Of the group here mentioned, each has found his individual style and his personal solution. But they were all involved in the crucial struggle for identity. The *Négritude* movement of the French territories never had any followers there because some of its simplifications were not acceptable. Nevertheless, Nigerian artists had to ask themselves some of the same questions: What is our heritage? How much of it is relevant today? Is traditional African art

still meaningful in the twentieth century? What do we owe to Europe? What are the implications of using a foreign technique? What new role should or could the artist play in modern Nigeria?

The answers differed from one artist to another. Few believed they had found a 'solution'. But it was the type of question that was being asked that was new, and that paved the way for the breakthrough. The time had gone when the past was rejected and people believed in a naive concept of 'progress'. The artists had become self-conscious and open minded, deliberately exposing themselves to the influence and impact of the two cultures. Sometimes the synthesis was artificial. But independence had now helped them to gain a new confidence and conviction and more often than not the synthesis was genuine. Certainly the Nigerian artist had become chiefly concerned with his own problem of identity and his artistic integrity, and his production was less geared to the potential European client. He had come of age. At this stage we should at least mention the forerunners of the new artistic movement. It is impossible even to think of Nigerian art without the colourful personality of **Ben Enwonwu**. Unfortunately this highly talented Slade-trained painter and sculptor made his name a bit too early. Nigeria was hardly ready for him. After an astonishing success with his first one-man show at the Apollinaire Gallery in London he returned to colonial and philistine Lagos. The government gave him a big job by making him Federal Art Adviser, but the city did not provide the right climate for a modern artist. His public consisted of colonial Europeans on the one hand (usually anxious to get some very exotic, African picture) and bourgeois Nigerians (usually interested in a tame portrait or landscape). I know this is an oversimplification, but the situation was sufficiently like this to induce Enwonwu to work in two very distinct styles all the time, one of which (the realistic one) he called the 'European' style, the other (rather more abstracted and transposed) he called the 'African' one. In an interview given to Peter Fraenkel which appeared in the magazine *Ibadan* in February 1958, Enwonwu declared that 'he could switch from one to the other just as other artists might do one work in stone and another in bronze'. Though Enwonwu became involved in executing a lot of routine commissions that allowed him little or no artistic freedom (a statue of Queen Elizabeth and several of Dr. Azikiwe, the then President of Nigeria), this remarkable man is still capable of surprising us with extremely fine work from time

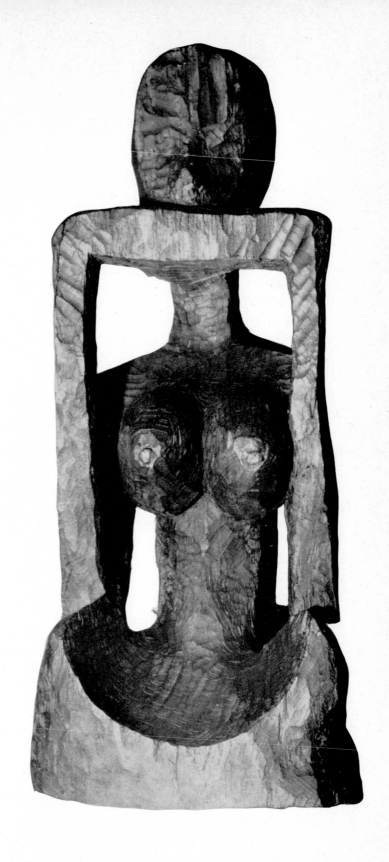

27 Ben Enwonwu
Wood carving (Nigeria).

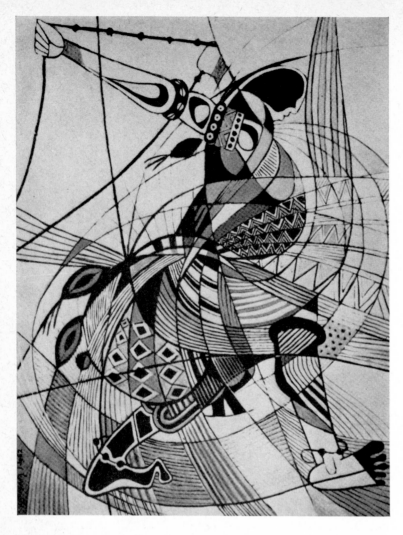

28 Tall Papa Ibra
Gouache (Senegal), 1962.

to time. He will be remembered not only as the creator of some very fine sculpture, but also as a pioneer who first showed the Nigerian public that a modern approach was possible.

In French-speaking Africa the visual arts were never found to be as congenial a medium of expression as literature. The two pioneer Senegalese artists are Tall Papa Ibra and Iba N'Dyaye. Ibra is a competent artist and draughtsman whose work is very self-consciously African and a little slick in execution. The impact of early success was described by Tall Papa Ibra in an interview with Irmelin Hossmann in *Afrique*. He explained there that he had obtained recognition with a certain style and that he was not going to change it as long as his public was content with it. It is true, of course, that it is a good thing for an artist to have rapport with his public, but there is also a great danger of an artist trying to be 'popular' and therefore becoming insincere.

Tall Papa Ibra's best-known colleague is Iba N'Dyaye, an artist with a great sensitivity to colour and paint. His rich impressionist technique was well suited to his earlier pictures, landscapes and images that were in a frankly Western tradition. More recently he has changed his theme to produce a more 'African' imagery, but oddly enough, he seems much less at home in this manner.

In the Cameroons, Didier Etaba, a much younger artist, has experimented rather successfully with the adaptation and transposition of mask shapes. They are surprisingly similar to the work of Jacob Afolabi in Oshogbo, though there was clearly no contact. It is too early, however, to assess the work of this young artist fully.

Most of the artists who emerged in the early sixties in West Africa were painters. The tradition of wood carving is too overpowering there. It is extremely difficult for a young artist to free himself from such an intense and revered tradition.

Nigeria has produced a great many carvers from Benin who have settled in Lagos and who are working for the European collectors there and occasionally for architects and the government. Quite a few of their works can be seen on public buildings and in public places. But few of these are satisfactory. Most of these carvers are folksy, deliberately cashing in on the European and American desire for *genuine* indigenous art. Many of them are, in fact, little better than the Makombe carvers described by Stout. Only Festus Idehen has emerged from this school with distinct possibilities. His friend Paul Mount, former director of the Art Department of the Yaba Technical College, wisely introduced him to cement sculpture, and thinking in a new medium, Idehen arrived at new forms.

The most distinguished sculptor in West Africa is the Ghanaian **Vincent Kofi**. Kofi qualified at the Royal College of Art in London in 1955 and has been an art teacher in a training college ever since. His first important work was a group of more than life-size wooden figures, which were displayed in Akuafo Hall at the University of Ghana. These carvings have preserved the organic shapes of the tree trunks from which they were cut and they have a certain archaic power. Their very scale and monumental severity distinguish them from every form of traditional art in Ghana or West Africa. *The Drummer* stands in an attitude of invocation. His face is turned upwards, his large bulging eyes stare at the sky. The soft, heavy lips are loose and expectant. The heavy fists

and the vigorous bend of the left arm convey a feeling of power. On the other hand, the feet are placed gently on the ground and the figure rises on a softly twisting axis from the soil. There is subdued potential power there, tamed by a humbleness of expression. The *Hornblower* has the same heavy proportions, the same rough surface treatment. But this figure rises straight from the ground and the horn towers club-like over the player's head. One seems to hear the shrill, piercing note coming from the horn. *The Dancer* is heavy and static, like a caryatid rather than a dancer. The tall, heavy woman looks pregnant. One arm is raised above her head, the other rests heavily on her hip. The mood of this figure is suggestive of a mother goddess, or an archaic earth deity.

Christ is as heavy as a Japanese wrestler, and his hands and feet are deliberately modelled on elephant feet. This is no image of the gentle, suffering saviour, but rather of the all-powerful God, the rock supporting the world. The most delicate figure of the group is *Mother and Child*. It is the only one that is slightly smaller than life size. It is executed in light-coloured Odanta wood and Kofi gave it a rather fine, smooth surface treatment. There is great gentleness in it. The mother presses the child to her breast with large clumsy hands. Her heart-shaped head, with the large receding forehead, is gently inclined, the eyes dreamy. The child is staring away from the mother in another direction. This tender and forlorn-looking piece is one of the most moving Kofi has ever made.

In his book *Sculpture in Ghana* Kofi has theorised on Ghanaian art and its position in relation to European art. Whereas in European art the factors of form and technique 'are often developed to coldly scientific limits' and seem to 'dominate the poetry', in Ghanaian art there is an 'obsession with poetic and spiritual themes'. In fact, 'form will look after itself'. In spite of certain differences in approach, Kofi does not wish to draw a hard line between European and Ghanaian art. He accepts the fact of Western influences, because 'no art is produced in a vacuum'. He feels that the Ghanaian artist needs the courage to select, reject and assimilate where necessary. Outside influences do not constitute a danger to a virile artistic tradition. But while 'we accept outside influences as inevitable . . . no virile tradition will commit cultural suicide by brainwashing itself and rejecting its past completely'.

Kofi tries to find a balance between the different influences he is subjected to and the book can be seen as an attempt to establish his identity. But Kofi is a doer rather than a talker.

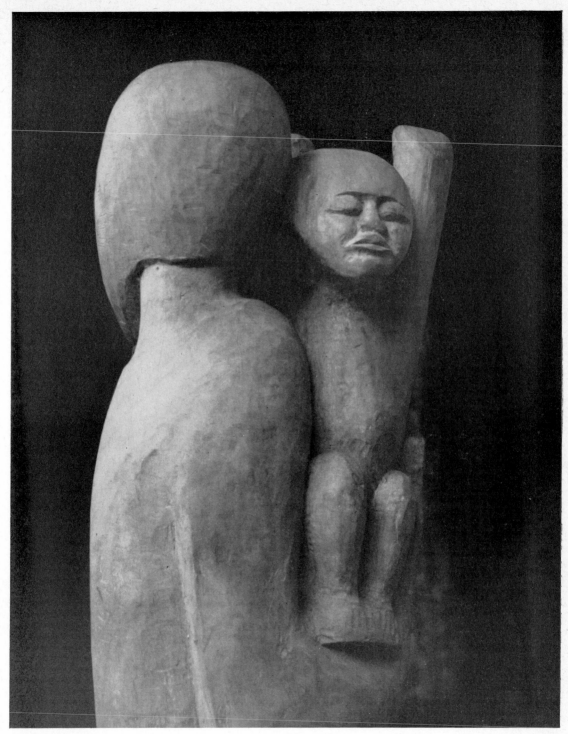

29 Vincent Kofi
Mother and Child (Ghana).
5 ft. 6 in. Wood.

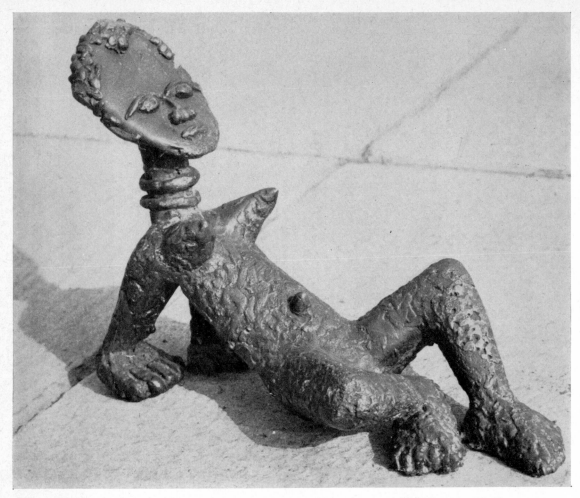

30 Vincent Kofi
Awakening Africa (Ghana).
Bronze.

By and large he has avoided the endless arguments on African personality, *Négritude* and the rest. He is a lonely figure in the West African artistic world and his true identity is best established in his huge images, which show a remarkable family resemblance to his own bulky stature. The dominant mood of the West African artist has mostly been the desire for the liberation from the foreign-imposed influences of Europe, the achievement of a cultural independence that complements political independence. The South African intellectual finds himself in a very different position. There the ruling white man is not trying to assimilate him. On the contrary, the policy of the South African Government is to isolate the African just as the white man has already isolated himself. With the sinister image before him of a dehydrated, suffocating European culture that has turned in on itself, the African vigorously rejects any suggestion that he should be relegated to a Bantustan, where he can 'develop on his own lines'. He does not want to live in the cultural ghetto into which he is being forced. From his position, tradition is

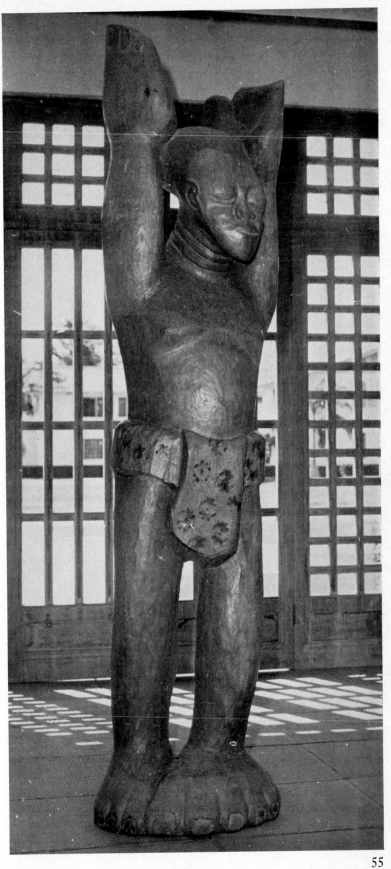

31 Vincent Kofi
Christ (Ghana). 8 ft. Wood.

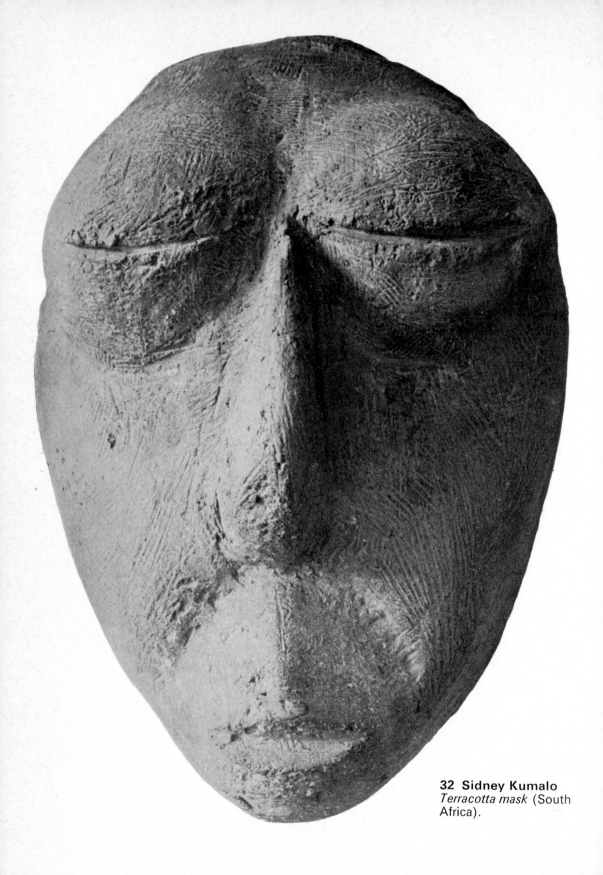

32 Sidney Kumalo
Terracotta mask (South
Africa).

narrow and stifling. He wants to break out, gain access to other cultures, to the wider world. In terms of creative activity this means, generally speaking, a total rejection of traditional African values, an orientation towards Europe, and even more towards America. For American culture is one in which the black man has achieved a certain measure of equality, has achieved success on the white man's terms. In West Africa most intellectuals object to the use of English hymns in church or British military music in their army. A typical South African reaction was that of the writer who told me: 'Why shouldn't I be allowed to listen to Mozart simply because I'm black?'

For some reason or other this particular mood has produced many writers but few artists. The most important exception is the sculptor Sidney Kumalo, whose work has recently been shown round the world. I met Kumalo only once, in 1961, when he was almost unknown. He was working in a studio of the Bantu Men's Social Centre in Johannesburg, where a number of Africans were given an opportunity to practise the visual arts. Shy and reserved, he stood between his large plaster figures of pregnant-looking women. They were heavy, yet tender. Kumalo is a natural sculptor whose feeling for the material is strong, and whose forms grow organically, defying theoretical considerations. Kumalo, whose work has recently been shown in London and New York, is one of Africa's most sensitive artists.

4 Finding a short cut

The affinities between traditional African art and contemporary art in Europe have been pointed out often enough. The most spectacular example of this affinity is the direct influence which the 'discovery' of African art had on the cubist painters early this century. But apart from this brief moment of actual contact and direct influence there appears to be a much wider affinity of spirit and of styles. African art has produced forms that we would describe as abstract, cubist, surrealist, expressionist, dadaist—in fact there is no modern art movement that does not find an echo in some African tradition or other. Should it not be possible then to create a kind of short cut from traditional African art to modern forms of expression? Is it necessary for *every* modern African artist to travel along the long road of alienation and assimilation in foreign-type schools and colleges, burdening himself with knowledge and ideas that will eventually prove to be irrelevant? Must all African artists go through this process and then *rediscover* the values of their own artistic heritage? Is the academic world the only possible gateway to contemporary art? Or are there ways of tapping the vast resources of talent that have remained latent since the slow disintegration of traditional society?

Antony Stout and Elimu Njau have pointed out that even among tourist artists like the Makonde of Tanzania the occasional art work emerges, despite unpropitious circumstances. Several European artists and art lovers, however, have set out to deliberately create a set of circumstances, an atmosphere, in which such a development could take place. The most successful were Pancho Guedes in Lourenço Marques and Frank McEwen in Salisbury. But theirs were not the first workshops or studio communities in Africa. At least two previous experiments must be mentioned here, even though they were not entirely successful.

First there was the studio of P. R. Defosses in Elizabethville which later became the Académie Officielle des Beaux-Arts under the direction of M. L. Moonens. A first batch of students left the institution in 1958. All the work shows a

strong family likeness and seems to indicate that a strong influence was exerted by the teachers. All the work is decorative and two dimensional and there seems to have been strong emphasis on the applied arts. None of the students seems to have found a way towards really personal expression. The possible reason for this might be found in an article by Emma Maquet that appeared in *Jeune Afrique* (No. 29) in 1958: 'It is indispensable that artists emerging from the Academy remain under the patronage of M. Moonens who was able to develop their talents with such a sure hand.' This seems to indicate a degree of paternalism that could have proved oppressive. Even more dubious is another statement made by Emma Maquet: 'The main teaching effort in the academy is not directed towards technique, but towards something much more basic: Western aesthetic values. Historically the African group possesses nothing similar. In fact it is very likely that the masterpieces of African art were created under some mystic, religious and social impulse, and not really an aesthetic one.' This reflects an attitude that would almost certainly lead to the imposition of ideas on the student. The Académie des Beaux Arts in Elizabethville produced some attractive work, much of which could have been suitable for textile design or commercial art. The Academy failed to produce contemporary artists of any stature.

Much more famous was a similar experiment carried out by the French painter Pierre Lods in Potopoto, a colourful suburb of Brazzaville. Whereas the emphasis in Elizabethville was on the decorative and naïve, the Potopoto school was illustrative and exotic. Lods gave his artists bright gouache colours which they applied to black or coloured paper, a technique that lends itself to quick, decorative effects. The Potopoto school combined a romantic, even exotic vision of Africa with a somewhat rigid stylisation. Most of the work that emerged from this school was decorative and elegant rather than inspired. Recently a Potopoto artist called Wassa became famous by winning the graphic prize at the Dakar Festival. His semi-abstract compositions seem to be influenced by Soulages. The work of Potopoto proved so successful with the Europeans of Congo-Brazzaville that hundreds of young men began to imitate the style. These pictures were hawked all along the West coast from Léopoldville to Dakar in their thousands. From excess, our eye has been blinded to whatever virtues the original school may have had. Undoubtedly the Potopoto school had vigour and technical competence, but it was slick to start with and produced a school and a style

rather than individual artists. There was considerable talent there all the same, which was proved by the readiness with which some practitioners later responded to a simple etching technique that was taught to them by Rolf Italiaander. The aims of the school were partly defeated by the unhappy circumstance that the tourist demand for the most facile works was enormous, while the more discerning collectors

33 Valente Malangatana
Dentist (Lourenço Marques).
Oil.

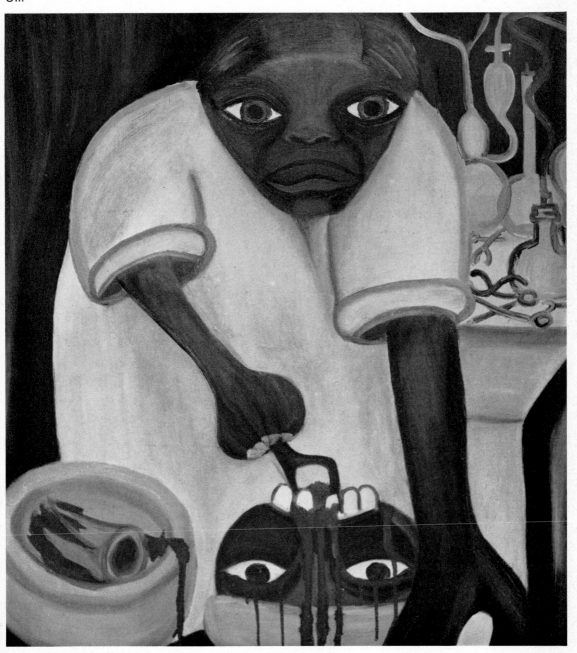

were few and far between. Pierre Lods has since left Brazzaville for Dakar where he has opened a very successful tapestry weaving school. This school is now being run by Tall Papa Ibra, while Lods continues with a Potopoto-type workshop. The Muslim mentality of many Senegalese artists seems to respond better to Lods's demand for decorative stylisation. Many of these young Senegalese artists, like Seydou Bary, produce attractive work.

More favourable circumstances probably prevailed in the relative isolation of Mozambique, at Lourenço Marques. This attractive little seaport with its Mediterranean climate is the home of a remarkable Portuguese architect, Pancho Guedes. Guedes is easily the most adventurous architect in Africa. His buildings are treated as sculptures rather than mere 'machines for living in'. The dominant influence on him was Gaudi, but Guedes's buildings are more disciplined without being less imaginative. One is surprised that he was able to sell his most unusual ideas to so many clients in Lourenço Marques. But it is no exaggeration to say that the numerous Guedes buildings—flats, terrace houses, hotels—have become the most prominent and exciting features in the town. Guedes is also a painter, and during the long years of his stay in Lourenço Marques he has taken a great interest in the activities of young local artists. To visit his house is like visiting a studio: painters, sculptors, and embroiderers are at work all over the place. Guedes holds no formal classes, but encourages, criticises, buys work and sometimes provides a monthly allowance that will enable the artist to work full time without financial worries.

By far the most interesting artist discovered by Guedes was **Valente Malangatana**. Malangatana showed Guedes some pathetic little drawings when he was working as a ball-boy at the Lourenço Marques club. Guedes found Malangatana's personality more promising than his work—but soon their association produced the most remarkable results. It was not so much that the young painter had found a teacher, but rather that for the first time he found himself in an environment where art mattered. His family had accused him of 'always playing'. There he met people to whom his work was important, people who lived with art and who were willing to spend time and money in helping him. For the first time he came into contact with other serious artists and he was soon caught up in the feverish activity of the architect's studio. Malangatana has described his background himself in a short biography which is worth reprinting here:

'I was born in Marracuene, in the Regedoria Magaia, under Chief Diqua Magaia on June 6, 1936, on Sunday morning. According to what my mother says, I was always with her and always did with her the work she used to do, that is: going with her to the field, carrying water, going to the bush to cut wood for the cooking, picking mushrooms for lunch or dinner.

'For these reasons I was almost like a girl. . . . It was only when I started school and got used to my companions that I improved, but I was a cry-baby and very soft and did not know how to fight, and I was even nicknamed Malenga, or girl . . . My mother came from another part of the country to marry my father. In her homeland, according to her and confirmed by me, because I remember having gone there with her when I was already able to see and remember what I saw, the girls were very keen on art work; even after they married they continued to do ornamental work, which is usually done with beads on calabashes, belts for women and men, wide necklaces for women and babies, and also bracelets made of beads for witchdoctors. My mother not only knew how to do this but also how to sharpen teeth. . . . Besides this she did tattooing on stomachs and faces. She used to make sewing thread from pineapple and sisal leaves.

'I went to school in 1942 because my mother wished it, while my father was in South Africa working in the mines . . . At this school in the Swiss Mission I had a very good teacher. This teacher loved teaching and he also had a great gift for drawing, basket-making and other handwork . . . Here in this school I first saw pictures in books, but I did not believe they were drawings, and also saw some drawings done by the teacher's brother who had already finished studying at this school and was in the town . . . After I had passed from the first grade to the second and from the second to the third, this school was closed, unfortunately for us all, because the teacher left. Two years later, that is in 1947, I went to a Catholic school which I did not like so much as the other. I had no ability, but in spite of that I did not stop drawing on my own, chiefly on the sandy paths for want of paper. During this time at school, being together with several boys, I learnt to play some football and other games . . .

'A bad period for me. My mother went completely mad while my father was on his way back from South Africa, arriving a few months later. It grieved me very much when she became like that. It happened one night when I and the children of another wife of my father's had been as usual to play some distance from our house where we lived far from

63

everybody. When we returned that evening as I came into the house where I slept with my mother, I heard a voice calling me. It was the voice of my half-brother and my mother was also shouting: "My son, come to me for I am dying, your brother was killed because he was the cleverest in this house and was envied by this woman who used to call him 'white man'", pointing as she spoke to another wife of my father's... My aunt found a witchdoctor who took my mother in, and she stayed there having treatment for a long time . . . I was staying with my aunt and was attending the Catholic school... On religious holidays I used to decorate the house according to what I saw in the Church and she used to get very annoyed when I lit candles inside the house because she was afraid the house would burn down. So I made a shack outside where I could do everything I liked, where I hung holy pictures and other photographs which I cut out of magazines and also some drawings I made of various religious images which I copied out of books and catechisms . . . At this time my mother returned to where she was married, and my father went away again without leaving anything for me. However, when he got to South Africa he sent me two pairs of trousers—they were the same but were labelled, one for me and one for my half-brother . . . I then came to the city. When I arrived here, I worked as a children's servant alternating with going back home to teach in the Catholic school, when I earned only 40 escudos (ten shillings—$1.40) per month, which to me was a lot. I helped my mother with the little I had, while she fed me

'Returning to the city, I gave up teaching and went to work in a Coloured household where fortunately I was well-treated but, where, unfortunately, I had no time to go to school, although it was very near . . . In June 1953 I went to work at the Lourenço Marques Club after a short rest at home, during which time I decided to go with the girl who would not leave my heart, Cicilia Matias Machiana. In the Lourenço Marques Club I started by working as a ball-boy and cook for the servants, and I began learning English . . . During this time I used to draw a lot when I saw many drawings done to decorate the rooms for dances. . . . And I studied, I went to a good night-school with a good teacher, so that my drawing improved and my pleasure in drawing increased . . . I was drawing in charcoal and painting in oils, and everyone who saw my work and ideas admired them and encouraged me . . . I painted furiously, rather forgetting to visit my parents and my wife. . . .

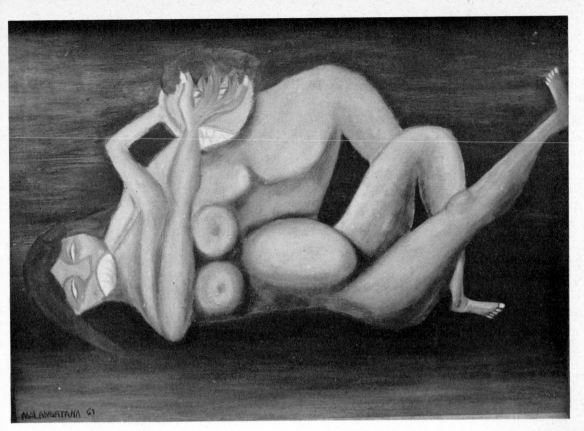

34 Valente Malangatana
Rape (Lourenço Marques),
1961. Oil.

'A few months later, in October 1959, I was discovered
painting at night by the architect Miranda Guedes. He ad-
mired my pictures and exchanged words with me . . . At
this time too, this architect used to buy paintings from me to
help me . . . Before the end of 1960 the architect told me that
he would like to help and arranged for me to leave the Club
and give up my contract at the end of January 1961, so I could
work all the time . . . He offered me a studio and a monthly
allowance, for which I and my family thank him from the
bottom of our hearts. In the studio I started receiving visits
from students . . . Now and then I wrote poems, as I had
already been doing before, and these, and this autobiography,
I wrote in Portuguese—they have been translated by Mrs.
Dorothy Guedes and Mrs. Philippa Rumsey. I was always
different from those who saw me wasting night after night
drawing with a pencil trying to tell stories by sketching on the
paper. When I came to the town there were always people who
attacked me for painting and drawing because in the view of
many it was just playing about—indeed it was playing, but
seriously, was always my reply to those who attacked me.

'Since I do paint for pleasure, not as a profession, but
because I love art and poetry. Apart from this, poetry is art

written on white paper without colour and in repeated letters, but poetry in a picture has life, smell and movement also . . . and I will even say that wherever I am, I shall be painting...'

Malangatana's work has been described as surrealist, and there are in fact some surrealist elements in it. The everyday world is invaded by spirits and monsters, the boundaries between reality and the supernatural do not seem to exist. But Malangatana is not trying to shock us deliberately. There are no self-conscious juxtapositions, the horrors and supernatural fantasies are not invented, they are lived. Witchcraft was a common and everyday phenomenon in Malangatana's childhood. He is a Christian of course and his mission education quickly and effectively estranged him from his native culture. The gods and myths of his people are no longer known to him and they never feature in his work. As among many Africans of his level of education, however, they continue to figure in his imagination as an unknown quantity, as a complex of fears and an impenetrable world of demons, spirits and witches, which—being a Christian—he has not learned to master.

His witchcraft pictures are as powerful and as moving as Hieronymus Bosch. The canvases are densely populated by human beings and spirits, and are splattered with blood and exude fear; the Christian symbols give the whole a particularly sinister aspect, like a representation of a black mass. Somewhere in the midst of the confusion and suffering we see a portrait of the artist himself, weeping tears of blood. Apart from witchcraft his major theme is woman. His romantic, mystical adoration of women is beautifully expressed in a poem of his which appeared in *Black Orpheus* No. 10:

> In the cool waters of the river
> we shall have fish that are huge
> which shall give the sign of
> the end of the world perhaps
> because they will make an end of woman
> woman who adorns the fields
> woman who is the fruit of man.
>
> The flying fish makes an end of searching
> because woman is the gold of man
> when she sings she even seems
> like the fado singer's well-tuned guitar
> when she dies, I shall cut off
> her hair to deliver me from sin.

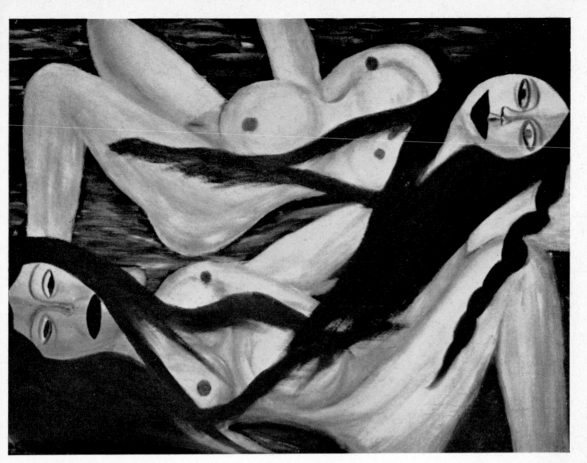

35 Valente Malangatana
Two Friends (bodies are
bright yellow) (Lourenço
Marques). Oil.

Woman's hair shall be the blanket
over my coffin when another Artist
calls me to Heaven to paint me
woman's breasts shall be my pillow
woman's eye shall open up for me the way to heaven
woman's belly shall give birth to me up there
and woman's glance shall watch me
as I go up to Heaven.

Woman appears here as a kind of redeemer and indeed
many of his female nudes evoke strong religious associations.
His picture *Nude with Crucifix* shows the short compressed
body of a thickset, reclining woman. The feet and most of the
head are cut off by the margin of the picture. The huge breasts
and belly form a kind of trinity with dark nipples and navel
as the focal points in the glowing, orange flesh. The cross
lies embedded between the breasts, the womb is dark, warm,
inviting, but the hand is a hideous, dangerous claw . . . Some-
times woman is the temptress, and pleasure and torture can be
perversely mixed as in the picture called *Rape* or in the very

67

F

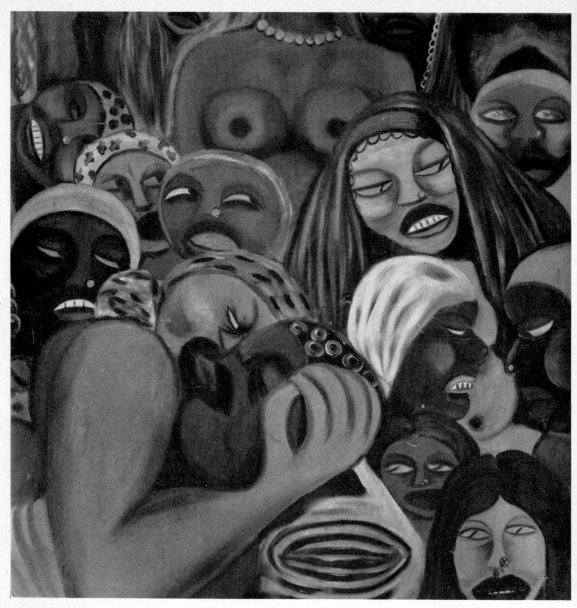

36 Valente Malangatana
Initiation (Lourenço Marques).
Oil.

weird *Temptation of a Clerk*. Jealousy and murder are frequent themes of Malangatana's too. He seems to have a kind of obsession with women's hair, which is mostly painted extremely long and flowing even when he paints African women. Julian Beinart has suggested that the long hair serves Malangatana as a kind of structural device, with which he ties his pictures together, as indeed he does in *Two Friends*, but it is also charged with erotic significance for him.

Malangatana's pictures may, or may not depict specific stories. One that has become particularly famous is told in a group of four canvases: 'This is the story of two lovers. They used to correspond by means of the woman's husband's hat, as her lover was the husband's companion at work. The woman writes the letter and then puts it in the husband's hat before he leaves. The husband arrives at work and puts the hat on the hat-rack. The lover knowing which was the husband's hat, takes out the letter, reads it, answers, and puts it in the hat. After work, the husband goes back home and when he arrives, puts the hat on the hat-rack. The wife waits for some time, and when her husband is not around, takes the letter, answers it and puts her reply in the hat. This usually takes place between two and three in the morning, when the husband is dead with sleep. And the husband at seven o'clock delivers the letter to his wife's lover. This went on for a long time. But one day another man, who was jealous of the lover's good fortune, and who used to see the letters being taken and put back in the husband's hat, told him about it. So the husband instead of going straight to work the next day, waited in the next room to see what would happen. Sure enough, his suspicions were well founded. And when he went home, he was feeling very sorry for himself. So he pretended to sleep and waited until three o'clock, by which time he knew his wife's letter would be written and placed in the hat. He then got up, and without his wife noticing anything, read the letter. He then felt even more sorry for himself, especially as he had himself been the post office. He killed himself by taking a tin of D.D.T. He left a note saying: "Luisa: Good-bye forever".'

Most of Malangatana's pictures are less literal; they may simply be called *The Woman Who Cries*, or *Lovers* or *Dentist* or *Initiation of the Bride*. Yet these are all charged with content and symbolism that go far beyond the depiction of an everyday event. The dentist becomes a torturer, his hand holding the drill has become a rather frightening mechanical claw like a crane, his eyes are evil, the patient is covered with blood.

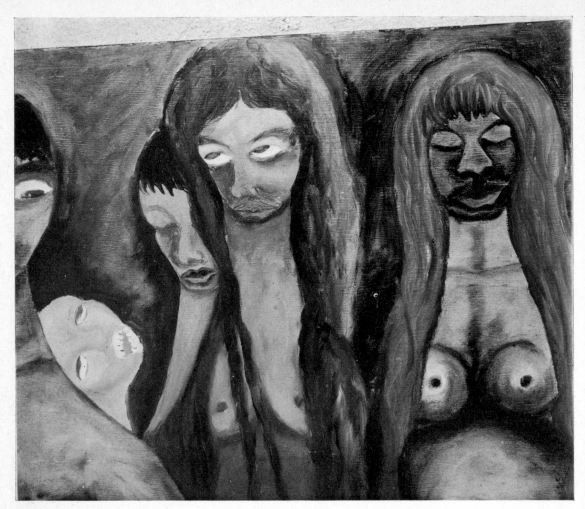

37 Valente Malangatana
Women (Lourenço Marques).
Oil.

The Initiation of the Bride is a sexual scene that takes place in front of a large crowd of laughing women. This is a luscious oriental scene, an exotic ritual rather than common inter-course. The bright orange body of the bride, who wildly takes the initiative instead of submitting passively, is set against a chequered background of faces, eyes and headties—a kind of human tapestry. *The Woman Who Cries* stands nude in a large room. Through the window we see the roofs and spires of churches. A bed and a table with drinks clutter up the room. In the background is a second woman, her back turned, but also

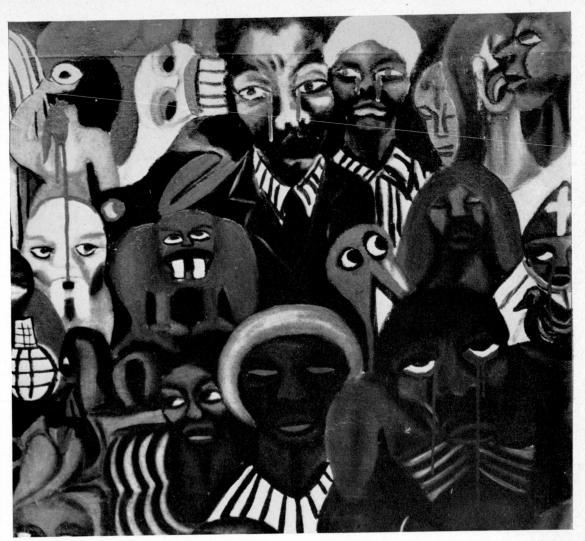

38 Valente Malangatana
Witchcraft (Lourenço
Marques). Oil. Scene with
self-portrait.

weeping. A highly suggestive picture. What is going on?
Malangatana offers no story here, no explanation, but he
heightens our curiosity and our anxiety by sprinkling strange
symbols round the canvas which do not appear to be part of the
scene, but which are inserted like hieroglyphic writing—a
doll-like face, music notes, a couple of crosses, a wine
decanter. . . .

Malangatana is a visionary, not a mere story teller. He takes
us into a world of horror and suffering and fear. A world in
which man's life is dominated by love and jealousy, by

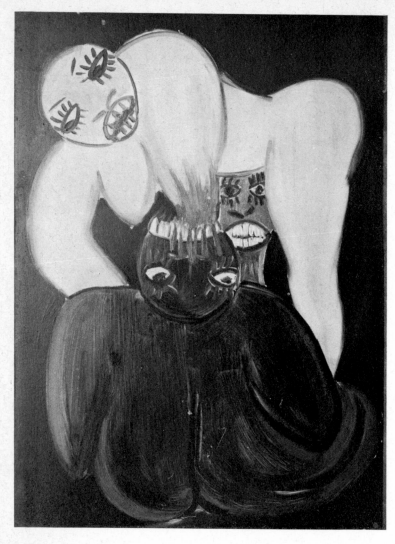

39 Valente Malangatana
Murder (Lourenço Marques).
Oil.

witchcraft and torture, by anxiety and perversion. Why is it
not repulsive? Why do we not recoil as we do when we see
some clinical photograph, or as we do when we see some of the
Makonde sculpture of Tanzania, which deals with similar
witchcraft scenes for the tourist market? I believe it is
because in this nightmare vision we feel the personality of the
artist himself. We are carried away by his passion, we suffer
with his torment and we long to reach his loneliness—and we
respond to his love and even to the tenderness that pervades
everything.

Malangatana may have been the first African artist to find
the short cut—to become a sophisticated artist while by-
passing education. I cannot describe here all the experiments
made in this direction. The Tanzanian artist Elimu Njau was
thinking along similar lines when he worked with children.
A very successful exhibition called 'Let the Children Paint'

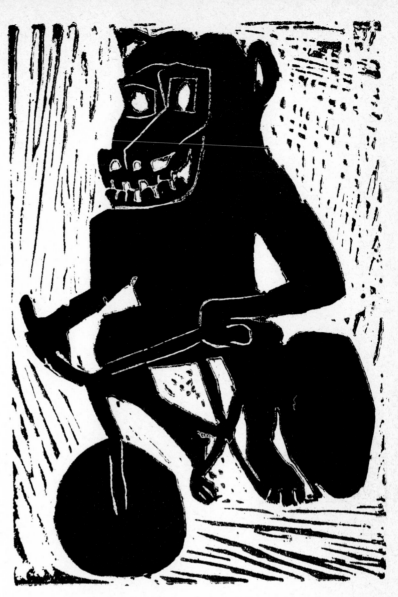

40a Hezbon Owiti
Lino-cut (Kenya), 1966.

toured Germany in 1963. He now runs a workshop with
adult students, but unfortunately no documents on this
enterprise are available to me.

The career of Hezbon Owiti, a young Luo from Kenya, is
full of promise. He was left at a loose end when he finished
primary school, like most of his fellow pupils. Unlike them,
he felt a strong urge to paint. He hawked his first clumsy
drawings around, trying to get advice and looking for op-
portunities to study. In the end, the South African writer
Ezekiel Mphahlele saw him. He felt instinctively that Owiti
had talent, and although he could not help him as an artist,
he employed him as a caretaker of the Chem Chemi art
gallery in Nairobi. Mphahlele was then director of the Chem
Chemi Club, which was mainly interested in developing local

drama and literature. Owiti spent two years at Chem Chemi, seeing many exhibitions and digesting them in his own way. His feeling for paint is instinctive, and though his compositions are simple, his canvases have a refreshing vigour about them. The Farfield Foundation gave him a six-month travelling scholarship which he spent in Nigeria, mainly Oshogbo and Ibadan. He returned home with a series of exciting lino-cuts and several exhibitions behind him. Like all the young artists who have found a short cut into art he now faces a difficult struggle for existence. The academically trained painter can always become a teacher or a designer. Young men like Hezbon Owiti are forced into the desperate position of trying to live off their painting. This is no easy thing in a country that has not yet evolved an art-loving middle class.

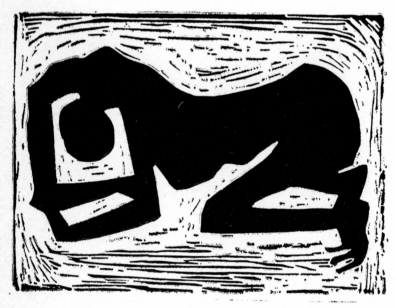

40b Hezbon Owiti
Lino-cut (Kenya), 1966.

5 The great excitement

The charming and attractive town of Lourenço Marques seems an appropriate setting for the emergence of new African artists. Not only do Pancho Guedes's buildings serve as a constant inspiration but there is a lively African community which paints the walls of its shantytown shacks with delightfully playful designs. Even if the charm of these popular paintings is very superficial, they are an indication of the reserves of talent waiting to be tapped.

On the other hand, Salisbury, the capital of Rhodesia, is a town so deadly bourgeois, so painfully respectable and sterile, that any form of artistic activity comes as a complete surprise. There is no Pancho Guedes there to break the monotony of the matchbox skyscrapers that dominate the boom town. The African 'locations' are perhaps slightly less poor, but they are rather more depressing than those of Lourenço Marques. The fact that this town became the scene of the largest and most successful art workshop in Africa is due entirely to the activities of one man: Frank McEwen, director of the Rhodesian National Gallery. McEwen had spent thirty years in Paris, some of them as *délégué des beaux arts* of the British Council. Few people were so closely connected with the great painters of this century. Picasso, Braque, Brancusi, and many others were among his personal friends. In 1957 he suddenly decided to leave his high-powered job in Paris and accepted the invitation to become director of the Rhodesian National Gallery in Salisbury. His real job was to administer the Gallery, which had a permanent collection of European old masters, and to import occasional exhibitions from Europe. The bewildered Rhodesians were subjected to a huge Henry Moore exhibition and to a rare collection of medieval French tapestries.

But this did not satisfy McEwen. He felt that the Gallery should serve the African community as much as the European one and he did not rest until school children and adults from the locations were among the regular visitors to the Gallery.

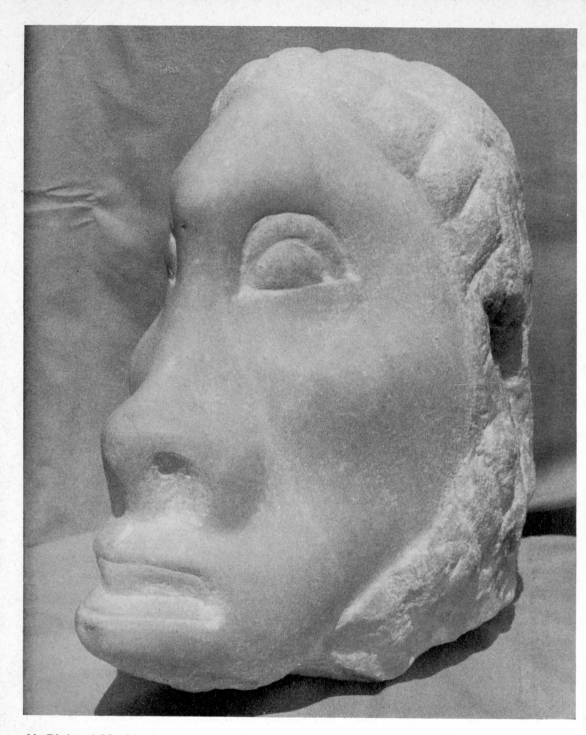

41 Richard Mteki
Head (Rhodesia), 1965/66.
16 in. Limestone. Collection:
G. L. Caplan.

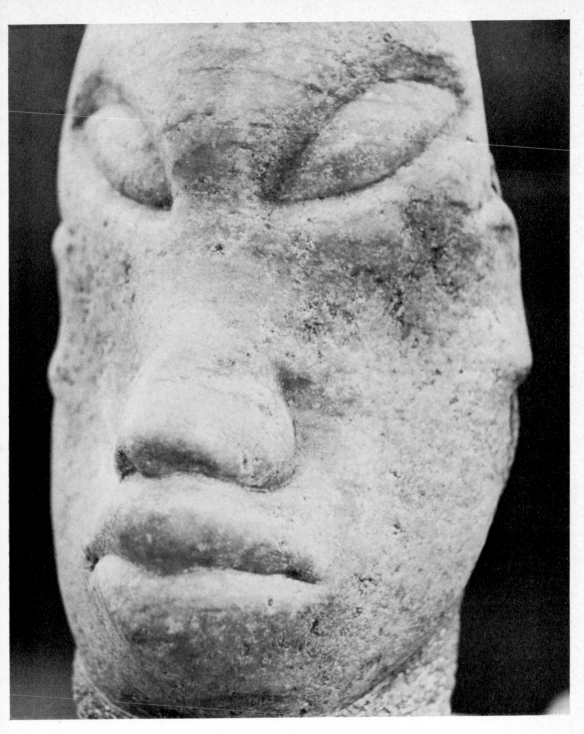

42 Boira Mteki
African Queen (Rhodesia).
19 in. Granite.

His real interest, however, was in discovering and encouraging local talent. Art work had hitherto been encouraged in Rhodesia by a number of mission schools and colleges, not always with very exciting results. Here and there, artists were working away in isolation, usually without encouragement and without customers.

McEwen's Gallery soon became the focal point of all these activities. Some artists were farm workers, others agricultural officials, one was a policeman. Some were mission-trained, others self-taught. Some worked in their spare time, others became full-time professional artists. Today, ten years after McEwen first went to Salisbury, the list of Rhodesian artists comprises at least a hundred names. Their work has been shown twice in London and a collection has been acquired by the Museum of Modern Art in New York.

The first artists to make contact with Frank McEwen were several agricultural officers in the Inyanga reserve who were carving soapstone as a kind of pastime. Mrs. Pat Pearce first brought a collection of their work to the Gallery and from then on they continued to send their work there for criticism and sale. Four of Rhodesia's best known artists belong to this group: Joram Mariga, Bernard Manyandure, Zindoga, and Denson Dube. The first painter of importance was Thomas Mukarobgwa, who was in fact an attendant in the Rhodesian National Gallery. His early drawings were childlike and pathetic, but McEwen saw the great potential in this artist very early on. He has become one of the most important painters in the whole of Africa. Nicholas Mukomberanwa was a policeman who had first been trained by the famous Cyrene Mission, but who later attached himself to the Gallery circle. Another missionary who encouraged artists was Canon Patterson, who collaborated for many years with Frank McEwen and from whose mission emerged Joseph Ndandarika and Boira Mteki.

During the first years, all the artists worked at home and they came when they wanted to present their work. Later McEwen opened a studio for five painters to work at the Gallery: Thomas Mukarobgwa, Charles Fernando, Joseph and Lucas Ndandarika, and Kingsley Sambo. Only quite recently was he able to open a very large studio in which many painters and sculptors can work.

The most recent group of Rhodesian artists was discovered more or less accidentally on a farm. The expatriate farmer brought a piece of sculpture to the Gallery which he had made himself, and mentioned incidentally that two of his farm

43 Lemon Moses
Head (Rhodesia). 9 in. Grey soapstone.

78

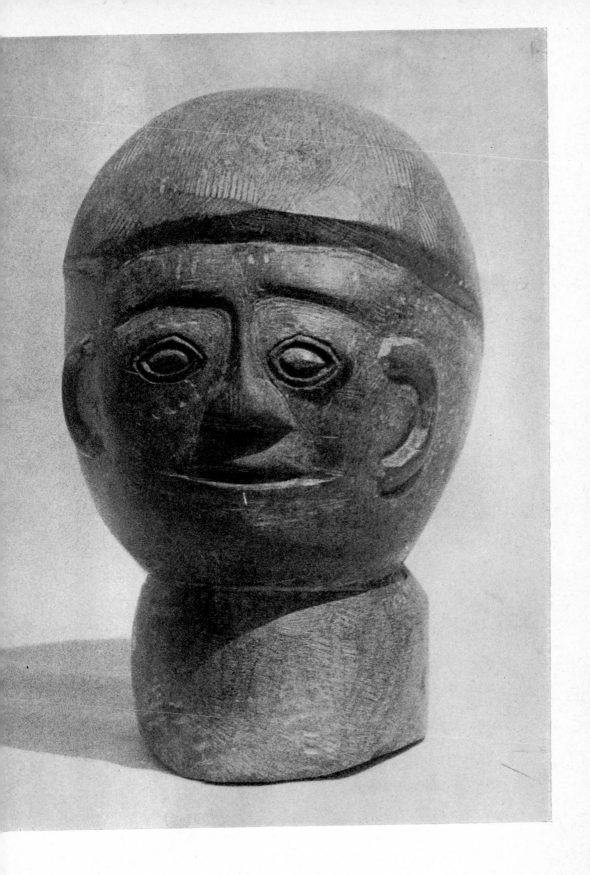

labourers were also carving. They turned out to be very charming artists, and the encouragement Frank McEwen gave them—Lemon Moses and Tamson—in turn encouraged others so that now a large group of carvers is working on that farm. The snowballing effect of McEwen's activity was really spectacular and much of the work produced is of the highest quality.

McEwen's method of working is extremely interesting. He believes strongly that nothing should be imposed on the artist, that any form of 'teaching' is in fact already an imposition. He sets no themes, makes no suggestions and insists that the

artists develop their own technique. He does exercise a very strong influence, however, in two particular ways. His tremendous energy and enthusiasm are infectious and few people have his gift of inspiring others with confidence and courage. It requires great faith to believe in the artistic possibilities of people who have no tradition to back them up and who live in a country as culturally bleak as Rhodesia. McEwen never faltered. He had the courage to believe in the Gallery attendant Thomas Mukarobgwa who started 'with a brand of adult child art'.

McEwen's second influence was that of a critic. He set high standards and condemned pictures that did not work, making the artists overpaint them. He taught them to apply severe criticism to their own work and insisted that they never sell anything they knew to be second rate. His constant approval or rejection subjected the whole of African art in Rhodesia to a continuous selection process, and according to the law of the survival of the fittest the work of these artists was almost bound to improve.

Many of these artists can now live on their work, but at the time of writing this famous art school is going through a crisis. The political climate in Rhodesia does not particularly

45 Denson Dube
Mouseload (Rhodesia.) 6¾ in.

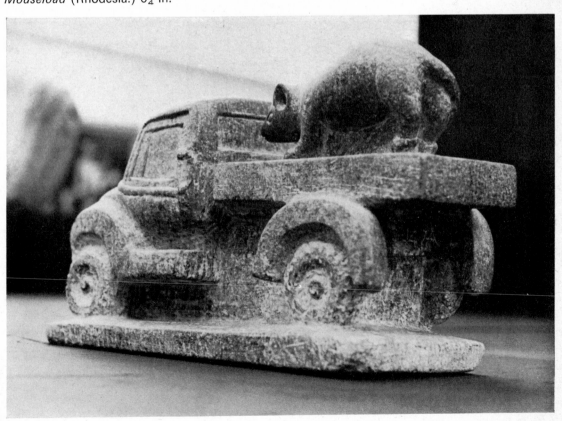

favour the encouragement of African arts. Government money is harder to get. Moreover, the sanctions imposed on Rhodesia hit the artists directly. Their work cannot be exported, and overseas visitors to the gallery, who until recently bought most of the work, are becoming less frequent because of the political situation. In such times of financial hardship it becomes increasingly difficult to fight the commercial pressure put on the artists by ruthless shopkeepers who offer large sums of money for tourist junk, rapidly turned out, that descends to the cultural level of the average white settler's home. Nor is it certain whether Frank McEwen will be able to continue his activity in Rhodesia. Even if he has to leave, however, he will leave behind him a monumental achievement, and I have little doubt that at least the best artists will survive on their own.

To discuss or illustrate all the artists of the Salisbury art school would require a whole book on its own. Within the scope of the present volume we can only show a few examples and my choice is obviously subjective.

The most interesting painter, I find, is **Thomas Mukarobgwa**, who, in McEwen's own words, developed from 'a brand of adult child art' to 'masterly and involved

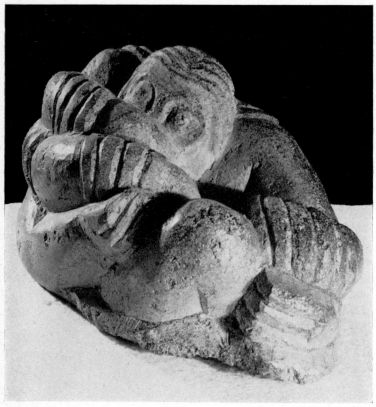

46 Nicholas Mukomberanwa
Entwined Figure (Rhodesia). Soapstone.

47 Nicholas Mukomberanwa
Man and Wife (Rhodesia).
7 in. high, 10½ in. wide.
Brown soapstone. Collection:
M. Mindlin.

sophistication'. His pictures bear titles like *Very Important Bush*, or *Enemy People*, or *Old Man Afraid to Cross*, and he is able to accompany them with long stories when required to do so. And yet they are anything but literary. Most of them are in fact near abstract, being built up from simplified tree shapes or landscape contours. Rarely do human figures appear, and when they do, they are clumsy little men in dark silhouette that seem to have strayed in from another world, or rather from another painter's work.

The most extraordinary quality of Mukarobgwa's pictures is its expressionist quality and, as a matter of fact, the strong resemblance to Emil Nolde. The thick flow of paint, the juxtaposition of dense oranges, yellows and blues, and the

83

G

48 Nicholas Mukomberanwa
Figure (Rhodesia). 9½ in. Red sandstone. Collection: T. Simon.

moody landscapes make it very difficult to believe that this artist has never even seen the German expressionists. These paintings are extremely satisfying, their composition is simple and decorative but they glow with saturated colour and the paint surfaces are rich and alive. He is one of Africa's most interesting colourists and his paintings are irreproducible in black and white. (See colour plates pp. 98–99.)

Among the sculptors, **Boira Mteki** is the best known and undoubtedly the most powerful. Mteki prefers the hardest granite to the smooth soapstone used by many Rhodesian artists. He likes to work on a large scale and his work is monumental in feeling even when he works on a smaller scale. His almost exclusive theme is the human head and he knows how to give it an archaic, brutal force. The eyes are set closely together under a narrow forehead, the jaws are wide and the lips thick, the chin swings forward with a violent thrust. These heads make us think of foreign cultures, of the huge stone figures on Easter Island perhaps, or the leashed power of some early Mexican sculpture. **Richard Mteki** was taught to sculpt by his brother Boira. Richard's style closely resembles that of his brother and has the same power.

The work of their colleague **Nicholas Mukomberanwa** is much gentler. There are some elements in these carvings, with their stylised, simplified human features, that are reminiscent of early Romanesque sculpture. Whether this is a result of his early training at the Cyrene Mission station is difficult to say. In any case, his work is not as static as Romanesque art, nor is it as static as traditional African art. Mukomberanwa's sculpture is full of ideas and invention, he has a great variety of attitudes and expressions and he likes to portray whole

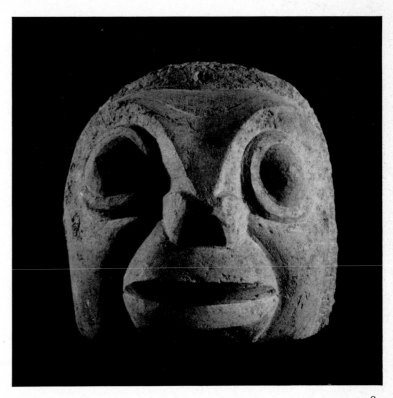

49 Nicholas Mukomberanwa
Head (Rhodesia). Soapstone.

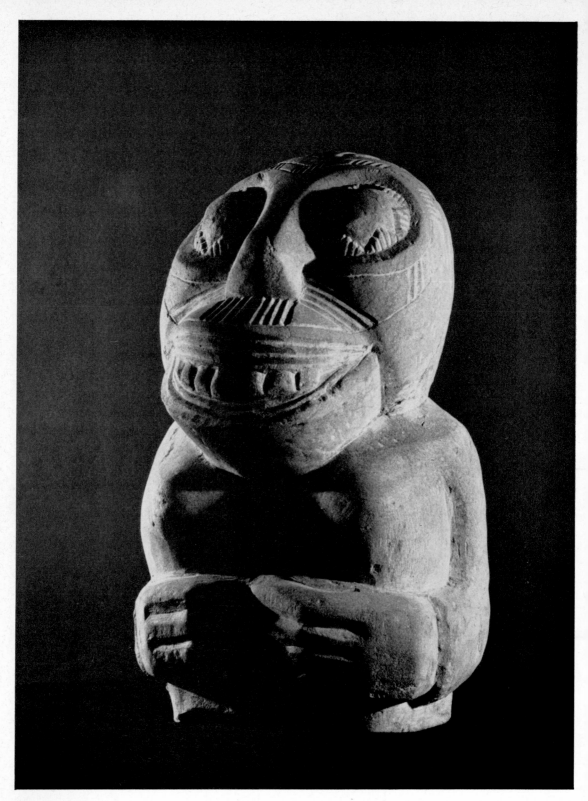

50 Nicholas Mukomberanwa
Baboon (Rhodesia).
Soapstone.

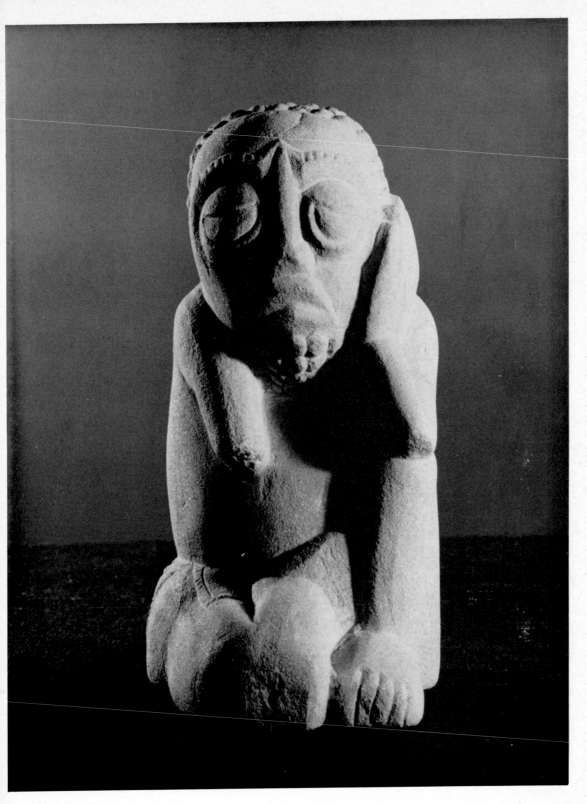

51 Nicholas Mukomberanwa
Thinker (Rhodesia). Sandstone.

clusters of intertwined figures. He works in many different stones, consciously using textures and colours. The mood of his sculptures is always meditative, sometimes religious, and they are of very high quality.

The work of **Joram Mariga,** on the other hand, an equally well-known Rhodesian artist, I find somewhat less agreeable. There is a smoothness of texture, a weird distortion of anatomy that is uncanny and unpleasant. The gestures and stances of his people are heavy and clumsy, their foreheads alarmingly small, their cheeks puffed or sagging, their short noses upturned and sharp. There is talent there, undoubtedly, but it almost seems psychotic.

One of the artists most recently added to the long list of sculptors associated with the Rhodesian National Gallery is **Lemon Moses.** His work is naïve and completely endearing. Lemon Moses, a farm labourer, carves little heads of lovable people. His technique is simple and contrasts with the polished professionalism of Mteki, Mukomberanwa and Mariga. There is also a new playful element, a sense of humour that is new in Rhodesian art but which has recently been picked up by others. The animal carvings by **Tamson** belong to the same school and even some of the older carvers, like the powerful **Denson Dube,** appear to have been influenced by Lemon Moses. Much of Dube's work is as intensely powerful as Mteki's. But some of his recent work, like the delightful *Mouseload*, show him closer to, if not influenced by, the more relaxed style of Lemon Moses.

Like so many others who have encouraged the arts in Africa, McEwen is fighting against time. He knows that political developments, commercialisation and bureaucracy are against him. But his earlier prophecy has been fully justified: 'While the great excitement lasts, and it will last for a full spell before institutional pomposity will set in, new and lively visions will be created'. McEwen has proved to us how much the 'great excitement' produced by a single man can mean in Africa.

6 Trying to tell the wood from the trees

Frank McEwen, trying to create new artists in the cultural desert of Rhodesia, could be compared to an Israeli farmer fertilising the Negev. Working in Oshogbo, a Yoruba town in Western Nigeria, it was rather a case of trying to tell the wood from the trees. There the cultural heritage is extremely rich. But it is not simply a case of an 'historic' town, and a 'museum' culture. The place is very much alive, teeming with activity, ready to absorb and try out new ideas. The cultural life of Oshogbo is a complex pattern of traditional, Western and hybrid forms of life and expression. Nothing there is set and conventionalised, so far. Everything is open, in a state of flux, of adjustment. An ideal situation indeed for anyone wishing to experiment and trying to stimulate. An ideal situation too, for a European or any outsider who wants to live in an African community, but not simply as an anthropologist who *studies* a foreign way of life and therefore adapts himself completely, but temporarily. There it is possible to live in the community without temporarily surrendering one's identity. One can become a genuine part of the community because one's very foreignness is appreciated and one is able to contribute to the life of the town. Western Nigeria must be one of the most rewarding places in the world for cultural exchange, a real melting pot of ideas, a cultural hothouse.

Oshogbo is a town of some 120,000 inhabitants. This sounds huge by most African standards, but among the Yorubas it is not unusual. For a thousand years they have been living in city states, not unlike the Greek polis. Each walled city of twenty, fifty or a hundred thousand inhabitants represents a more or less independent little kingdom, though some form of allegiance was usually owed to senior kings. At times such associations of city states held so tightly together that one could speak of an empire (the Oyo empire of the sixteenth and seventeenth centuries is a good example) and in such periods the overlord in the capital would have his representatives stationed in all the dependent towns and there was

something like a federal army under a joint command. Not even in those days, however, could one speak of a really centralised administration.

The ancient Greeks experimented politically with forms of monarchy, oligarchy and democracy. One could argue that the Yorubas evolved a system in which all these forms of government were somehow simultaneously represented.

The *oba* of a Yoruba town is both the political and the spiritual head. He usually claims descent from the founder of the community. There is, however, no father-to-son succession and the installation of a new oba involves a complicated election process. Usually there are three or four families of royal blood, each claiming descent from one of the sons of the mythical ancestor of the town. These families are entitled to propose a new king by rotation. Any male member of the family is eligible, provided his father is no longer alive. (If his father were alive, it would mean that the king could not be the *senior* person in the town—he would have to prostrate to his father.) The family may try to select from the thirty-odd eligible males in its midst, but the final choice belongs to the kingmakers, about half-a-dozen chiefs, belonging to different lineages. The choice must further be approved by the oracle, which represents the religious interests in the town, but even then popular disapproval can be expressed by processions of women or young men singing abusive songs and throwing sand at the candidate's house.

Once elected, the king's powers are very effectively checked by a large number of safeguards. He is chairman of the council of chiefs which also acts as a kind of supreme court, but the rule is that he must speak last in order not to prejudice the case. Real government is often vested in the secret Ogboni Society, an earth cult to which membership is attained through high office in other fields. Here the senior chiefs and major priests of religious cults meet to discuss matters of state and try any cases that could involve a death penalty. While most chieftaincies in the town belong to certain lineages, there are so many of them that almost every individual has access to some title or other. Furthermore, new titles are constantly being created by the king in order to give recognition and accord influence to anyone who has distinguished himself. The hierarchy is therefore extremely fluid and does not lead to a strict class system.

The people's influence makes itself felt in a number of ways. A certain night of the year is set aside for freedom of expression. Then the people can dance through the town and

abuse any senior holder of office with complete impunity. Any chief, including the king, can be destooled, or rather, can be forced to commit suicide if his tenure has been considered a complete failure. Furthermore, the praise singer, who is also a singer of abuse, has a kind of fool's licence at the royal court and it is often through him that the king and senior chiefs learn how the barometer of their popularity is fluctuating. Finally, the various trade associations are a powerful factor: the blacksmiths' guild, the hunters' associations, the women potters, the indigo dyers, the gari sellers. These associations are partly religious, the hunters and the blacksmiths worshipping Ogun, the god of iron. The potters and indigo dyers worship the goddess Iya Mapo. But these are also trade unions to protect the commercial interests of the group and strikes and trade disputes are as old in Yoruba country as the history of the people itself.

The Yorubas believe in a high god, Olodumare, conceived as almighty and all powerful and usually thought of as a sky god. However, he is abstract and remote and in practice the Yoruba deals with a divine mediator called an *orisha*. The concept of an orisha is complex, a number of ancient historical rituals and beliefs having usually been merged into one. On the one hand the orisha is a force of nature: thunder, the storm wind, a river, a rock. On the other, he is an historical personality, a warrior, the founder of a town, a culture hero. If one wants to probe deep enough, there are remnants of totemism too: the ram, the buffalo, the leopard and the elephant are now symbols and sacred animals of orishas.

A huge body of poetic praise names describes, addresses and interprets the personality of the god. The names are often very ancient, but new ones are constantly being added and the god's personality must constantly be reinterpreted. The orishas emerge as human archetypes: the extrovert, jovial, erratic but generous thunder god; the passionate, temperamental god of suffering; the wise introvert god of creation; the imaginative, unpredictable, malicious god of fate; the violent, aggressive, but creative god of iron. A symbolic figure puts their number at 401. The Yorubas believe that there are many ways of worshipping god, as many as there are human personalities, and each individual worships in his own fashion. Yoruba religion is not a code of moral conduct. The ethical laws of the tribe are protected by the ancestors rather than the gods. The Yoruba worship their gods not so much because they want to become better human beings but because they want to become richer human beings. The purpose of worship is to

H

become *like* the god, to share in his stature, to add an extra dimension to one's life, to live to one's fullest capacity, to gain intensity, to step up one's mental metabolism. This is achieved by complete identification with the god who corresponds most to one's own personality. People finding themselves through inheritance in the wrong cult find their lives going from disaster to disaster and have to be sorted out and redirected by the oracle.

It is this concept of religion that makes the Yorubas open to new ideas and new concepts. Any foreign god can easily be accommodated in this system. And ancient cults split up and divide into subgroups as new interpretations of the old ideas gain ground. In Cuba and Brazil the Yorubas found no difficulty at all in creating a complete fusion between their own religion and Catholicism—a Yoruba god was simply identified or associated with a Catholic saint. In Nigeria the ground was not as fertile for such syncretism. For there the religion was exposed not merely to Catholicism but also to numerous Protestant missions and above all to Islam, both infinitely less tolerant and flexible. It was the multitude of Yoruba gods and the innumerable shrines, not only in the market places and palaces of Yoruba city states, but also in every single household, that gave inspiration and practical purpose to this most prolific race of wood carvers.

Even now, after the countryside has been plundered by thieves (in the pay of European traders) and by more respectable but no less ruthless museum collectors, there are still innumerable carvings in use. They usually represent worshippers and priests of the gods, and less often the gods themselves. These Yoruba carvings are less abstracted than, say, Ibo masks or Senufo figures. The basic forms of this art are naturalistic. There is considerable anatomical detail: a face has cheekbones, eyelashes, earlobes and other details usually omitted in the more geometric African styles. But the naturalistic forms are adapted and distorted to suit the carver's mood and expression. The head, seat of the spirit, is extremely large, sometimes one fourth of the body. The eyes swell out from the head and can even be hemispheres stuck on to the head. The ears are set far back on the head and may not even be visible from the front. The lips are simplified to two parallel lines. The forms of a Yoruba carving appear to be produced by a kind of pressure from within: forehead, eyes, breasts and belly are all pushed outwards and the surface of the figure has the tension of a blown-up balloon.

The figures are static, the weight is evenly distributed on

Plate I
Twins Seven-Seven:
The Anti-Bird Ghost
(Oshogbo).
Varnished gouache.

the short legs. The carver works the front, the back and the two sides, there is no twist anywhere in the body's axis. Yet a kind of inner tension is produced, resulting from the contrast in textures and proportions, in the degree of naturalisation and stylisation. The basic form usually has a smooth surface like a pebble, but hairstyle, eyelashes, pubic hair and tribal markings are impressed with deep, sharp incisions. The naturalistic detail of the eye, for example, contrasts with the set of parallel lines that hint at the toes, or with the combination of triangles representing the ear. The figures are calm,

93

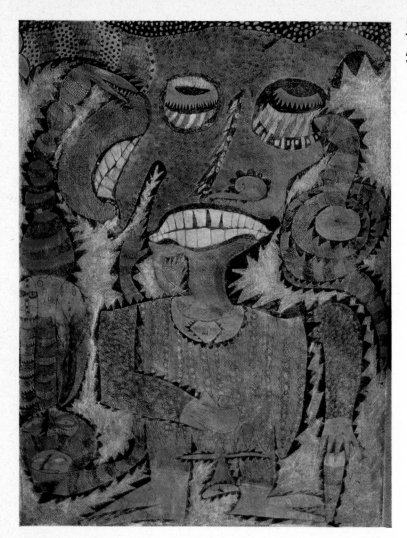

but not relaxed. There is a mood of receptiveness, and often a feeling of intense concentration.

Reliefs on palace doors can be illustrative and decorative. However, the figure carvings in the shrines of the orisha, which form the bulk of the artistic output of the Yoruba people, are anything but literary. They represent human beings, men and women, they explore a particular mood in infinite variations of style—but they refrain from telling stories and usually the identity of the carvings is unknown and appears to be of little interest to the worshippers.

Oshogbo is not an old settlement by Yoruba standards. The Oshogbans appear to have left Ibokun, the home of the Ijesha subtribe, late in the seventeenth century, following a chieftaincy dispute in which their candidate was unsuccessful. As often happened in such cases, when the defeated pretender had enough of a following, the people decided to found a new town. They wandered through the forest for years and tried

to settle in a number of different places. But the water supply always proved insufficient and they moved on until they finally came to the present site on the banks of the Oshun river. The *Ataoja*—this was the title of their king—decided to settle on the bank of the river itself. But the legend says that the goddess intervened in person, saying that the spot was sacred and she redirected him to a nearby hill. The Ataoja made a pact with the goddess promising to protect her sacred shrine and to pay homage to her every year. She in turn offered to protect the town. Both have kept their promise to this day. The place where the Ataoja first sat down by the river bank is now the site of the great temple of Oshun. The very stone is still shown in the open yard of the shrine. Every year the king goes down to the river to feed the fish, the special messengers of the river. A virgin priestess carries the sacred brass figures to the grove, and at the end of the festivities, in the privacy of the shrine, she will prophesy and make important pronouncements on the problems that might face the town in the coming year. But not only the handful of Oshun worshippers who are left today will go to the river on that day. Many thousands—Muslims, Christians and Orisha worshippers alike—will follow the king on his pilgrimage, for this has become the national day of Oshogbo, the day on which her sons return home from other parts of Nigeria or from Ghana to celebrate the foundation of their town. It is a great and exciting day, in which university graduates and illiterate farmers are united in celebrating an ancient ritual.

The goddess Oshun also kept her part of the promise. Oshogbo was never destroyed by an enemy. In fact it was there that the Fulani invasion of Yoruba country was stopped. The Jihad that had devastated the Northern part of Yoruba country was brought to a halt outside Oshogbo in a decisive battle in the 1830s and again in the 1890s. It was largely the presence of the powerful Ibadan army camping there that defeated the Muslims, but Oshogbo is full of legends about the goddess's personal intervention. One of the images in her shrine suddenly fell and broke its neck—and the oracle, thus warned, revealed the secret plan of a Fulani night attack. On another occasion, disguised as a food seller, the goddess herself went into the enemy camp and caused thousands to die from her poisoned dishes. Although the invasion was stopped, Islam later found its way into Oshogbo from the south. Indian missionaries had brought the Ahmadia sect into Lagos and from there it spread up-country. Today they probably form the largest group in Oshogbo but there are

numerous Christian communities, from the conventional Anglican and Catholic communities to the bizarre local sects like the Seraphim and Cherubim and the Christ Apostolic Church, who have added drumming and trance states to the Christian ritual as we know it.

During the last two decades the town has been immensely modernised and important social and political changes have taken place. There is now electric light in the streets and in most private houses. Piped water is within easy reach of every house. Government rediffusion boxes (rented out at 7s. 6d. a month) blare out cheap music (much of it foreign) and propaganda in practically every hut. The town has four secondary schools and primary education is more or less universal.

An elected council has now replaced the council of chiefs and the king himself has only a nominal function on it. The native courts can only try certain types of cases and litigants can appeal to a higher judicial authority. The assizes are held in Oshogbo and it is also the local headquarters for the posts and telegraph department and for the police.

Party politics has been active and violent—an important change from the past, when Oshogbo was considered a peaceful town, to the point of being called a town of women. Before the military government took over electioneering was carried out with vigour and often with clashes between armed party supporters. The great number of virtually unemployable primary school leavers supplied a large reservoir of potential 'party stalwarts' as elsewhere in Nigeria, who could be recruited into the private armies of ambitious local politicians. These politicians kept their gangs together by paying them danger money and by distributing hemp before important 'operations'. In spite of this political restlessness, cultural activity in Oshogbo has been lively and varied. Traditional woodcarving died out about a generation ago. But there is still a splendid brass caster in the area, Yemi Bisiri, whose imaginative works have already been described in an earlier chapter. There are still many carvings around, however, and there is a magnificent festival once a year in which the sacred images are carried in procession, with drummers, through the town. It is one of the most exciting festivals in Yoruba tradition, one that brings African art to life in an almost uncanny way.

The various masqueraders' societies are also very active: the king's own ancestors are symbolised by powerful masks, heavily dressed up in cloth, leather and bones, and charged with supernatural powers which make it necessary for the

Plate III
Muraina Oyelami:
City (Oshogbo).
Oil.

public to be protected from them by youths with whips who clear a large space in the market place in which they dance. Strange symbol of the times: the mosque looms large in the background over the dancers, and all traffic is diverted from the main thoroughfare by the local government police for several hours, to protect this ancient rite from interference. Another type of masquerade is lighthearted and satirical. These masks come out whenever invited by a patron and they entertain with comic sketches, mimicking animals and people. The grotesque figure of the policeman, usually appearing arm in arm with the prostitute, gives vent to public resentment of government authority. The Europeans are clumsy, walk about stiffly and shake hands, saying 'Howdoyoudo'. Their masks have enormous pointed noses and straight black hair made of Colobus monkey skin and they are painted pink or bright red.

There is no month without at least one major traditional festival being celebrated by the king. The worshippers of Shango, the thunder god, give magic displays in the palace grounds. They perform fakir-like feats—piercing their tongues with sharp irons or allowing two strange men to pound their chests with heavy wooden mortars. Throughout one glorious night the oracle priests recite the sacred poetry in which all

97

**Plate IV
Thomas Mukarobgwa:**
Landscape (Rhodesia).
Oil.

prophecies are embedded. They dance around a large wrought-iron staff on which sixteen oil flames burn. Each god's festival is celebrated by the king in public, but throughout the year innumerable private celebrations take place in the compounds. Almost every day and night the town throbs with drumming. If the visual arts have died, drumming is terribly alive. While there may be less orisha feasts now, the drummer has found new functions: he may play for politicians as well as for the gods.

These traditional feasts are only one level of activity in this lively town. The cocoa boom of the thirties and forties created a new middle class in Oshogbo. Rich farmers and lorry owners ('transport magnates' in local parlance) wanted to demonstrate their new position of influence in the town. Ostentatious building activity was their main status symbol. In the forties in particular huge mansions rose up all over the town and towered splendidly above the low rectangular mud compounds which included the king's palace. The 'upstair' house was the perfect symbol of success, even though people felt lost in the big mansions and seldom inhabited the top floors. Often the houses stand entirely empty, serving as monuments only.

Those were the great days of Yoruba architecture. The builders—usually illiterate—derived inspiration from the 'Brazilian' buildings in Lagos. They show all the features of Portuguese baroque which returning slaves would have seen in towns like San Salvador: pillars and balconies, arches and heraldic lions. The illiterate builders erected their mansions in mud or brick or stone. There were no limits to their imagination other than those imposed by the nature of the material. The purpose of the building was to be bigger, more

Plate V
Thomas Mukarobgwa:
Old Man Afraid to Cross
(Rhodesia).
Oil.

fanciful, more extravagant than the next man's. Oshogbo can claim some of the finest examples of this Yoruba baroque. The lighthearted dance music associated with that time and that class has become known as 'Highlife'. It would be a fitting name for the entire culture and the entire period. Highlife culture flourished until the days of independence. During the fifties one could go out any night in Oshogbo and find some half-a-dozen nightclubs packed with dancers swinging to the highlife bands.

But the sixties have seen the end of this culture: there is less money about and ostentatious spending is no longer possible for most people. The political unrest and the corruption following independence have created a new spirit of disillusionment and much of the old exuberant spirit has been damped. The very highlife music seems to have lost its spark, has become an empty formula. The people who now have the money—lawyers and politicians—are more bourgeois in the European sense, more respectable, far less imaginative. They build monotonous houses of breeze blocks, with glass louvre windows and furniture copied from the clumsy designs of the colonial Public Works Department.

There is one art form with roots in the highlife period which has survived the post-independence disillusionment, and which has in fact come to full bloom only during the sixties: the Yoruba theatre. The theatre, in the western sense, is not an indigenous art form in West Africa. The Yorubas have known ritual re-enactments of historical events and they have also known the satirical sketches of masqueraders. But formal theatre is a recent phenomenon. As in medieval Europe, the roots of the theatre must be sought in church moralities. It was the schismatic African churches who first

Plate VI
Muraina Oyelami:
Ajantala, the Forest Spirit
(Oshogbo).
Oil.

thought of familiarising their illiterate congregations with the Bible by putting on plays about *Adam and Eve*, *The Nativity*, *Nebuchadnezzar* or *Samson*. Hubert Ogunde, an ex-school-teacher and ex-policeman was the first to establish a professional touring company in the forties and he has been going strong ever since. Oshogbo has had its share of professional and amateur companies operating in and visiting the town. The plays have now become secularised. Some are satires on Yoruba types: the jealous husband, the stingy father, the reckless son; others are more aggressive and deal with topical events in Nigerian politics. In recent years Oshogbo has become the most important centre of Yoruba theatre with its two most brilliant and rival exponents, Kola Ogunmola and Duro Ladipo, both operating there.

So far, I have attempted to give a brief survey of the cultural background of Oshogbo. What I have said could apply equally well to a dozen or more Yoruba towns. Abeokuta, Ijebu Ode, Ilesha, Ado-Ekiti and many more would fall into the same pattern, would show the same variety and complexity and the same intense activity. It was perhaps an accident that Oshogbo rather than some other Yoruba town became the seat of the Mbari Mbayo Club and the scene of the great theatre revival, and one of the most important artists' centres in Africa.

7 'When we see it we shall be happy . . .'

One of the factors that singled out Oshogbo from other towns was the foundation of the Mbari Mbayo Club. The original Mbari Club was founded by an energetic group of young writers in Ibadan in 1961. Wole Soyinka, John Pepper Clark, Christopher Okigbo and Ezekiel Mphahlele were soon to be known beyond the frontiers of Nigeria. The Mbari Club ran a small publishing venture, an art gallery, and had an open courtyard in which plays could be performed. For several years it was a focal point of Ibadan life and of Nigerian culture in general. A description of its activities lies outside the scope of this book, though the impact of the club, particularly on the literary life of Nigeria, certainly deserves its own historian.

What is important here is that its existence prompted Duro Ladipo, a Yoruba composer, to start a similar club in Oshogbo. Ladipo was a primary school teacher with a great talent for music. For years he had been composing little songs and hymns for the church. In 1961 he produced a longer, more ambitious choral work which he called an 'Easter Cantata'. This work was performed with success in the Anglican All Saints Church of Oshogbo, but subsequently a long controversy ensued because some of the church elders objected to Ladipo's use of drums. After a long exchange about Yoruba church music in the press, I suggested to Ladipo that his music could be enjoyed equally well outside the church building. We then arranged performances in schools, on television, and finally at the Mbari Club in Ibadan. Ladipo saw the club for the first time in December 1961 at that performance, when it was about six months old. He immediately realised that this was a new type of platform for his own artistic activity which would make him independent of interference from cantankerous elders. However, it was clear that money for such a venture would be difficult to raise in a town that had never been heard of abroad. The Ibadan Club was heavily subsidised by the Congress for Cultural Freedom and later the Farfield Foundation.

Plate VII
Georgina Beier:
Sunbirds (Oshogbo).
Oil. 4 ft. 6 in. × 4 ft.

Ladipo was too inspired at that time to give up. He put his father's compound at our disposal and we converted an old bar into an art gallery and built a primitive stage in the back yard. The conversion was done on less than £200 and a modest regular grant was not obtained until some time later. Three months after the idea was born the club opened with a Yoruba play (more or less Ladipo's first, if we discount one or two abortive earlier attempts) and an exhibition of paintings by Susanne Wenger, the Austrian artist who had by then already been living for ten years in Yoruba country and whose contribution to the cultural life of Oshogbo will be discussed in a later chapter.

The Mbari Club in Oshogbo turned out to be much more successful than we had hoped for. It was not simply a rendezvous for intellectuals, like the Ibadan Club or the intimate theatre clubs of Europe. Situated on the main road of Oshogbo and near the market it was well placed to attract a wide range of people and our exhibitions were soon crowded by market women with their trays on their heads, hunters already carrying their guns on their way to take up duty as night guards of the town, chiefs and kings in full regalia and preceded by their drummers, schoolteachers, children, farmers, politicians, hooligans—in other words, the club really became part of the town. The fact that Europeans and Americans soon discovered it and made pilgrimages from

Plate VIII
Georgina Beier:
Octopus and his friend Bird
(Oshogbo).
Oil. 4 ft. × 4 ft.

Ibadan or even Lagos could not alter the fact that it was a cultural centre whose activities were directed primarily towards a local public.

There was no need to make specific concessions to the public. We exhibited many of the artists who were discussed earlier in this book: Malangatana, Vincent Kofi, and even one or two European artists alternated with local talent that was soon discovered. In the theatre, Ladipo's group soon broke away from social satire and he tackled more ambitious historical themes, which made it necessary for him to study traditional drumming, poetry and dancing. An entirely new Yoruba music drama was evolved and two of his productions, *Oba Koso* and *Eda*, became famous on two European tours.

The Ibadan Club, though situated in the heart of Yoruba country, had been called *Mbari* which is an Ibo word from Eastern Nigeria and which means 'creation' or 'the act of creation'. The intertribal and indeed international character of the club was emphasised by this choice. In Oshogbo, however, the illiterate market women were puzzled by the strange word and in typical Yoruba fashion they reinterpreted it by pronouncing it with Yoruba tones; they called it *mbari mbayo* which means, literally: when we see it we shall be happy. The name stuck and in the end it served well to characterise

**Plate IX
Uche Okeke:**
Mythological Creature
(Nigeria).

the different natures of the two clubs. The theatre was for a long time the centre of activities in the club and the art school partly evolved because we felt the need for producing local artists who could design scenery for the theatre. The artists were discovered—almost systematically—in a series of summer schools, and they were later grouped in permanent workshops. The idea of summer schools was actually pioneered in Lourenço Marques by Pancho Guedes and his South African architect friend Julian Beinart. During a visit to Lourenço Marques I saw the fascinating results of their first experimental school held in 1960 and I was able to have them invited to Ibadan in 1961 where they held a first school at Mbari Ibadan. In 1962 Julian Beinart returned for a second school, but this time he was assisted by the West Indian painter and scholar Dennis Williams.

Plate X
Jimoh Buraimoh:
Bead Work on Cloth
(Oshogbo).

Beinart's summer schools were primarily held for practising artists and art teachers. Their purpose was to shock people out of their conventional attitudes, to make them understand the mechanics of painting, and to teach them to see form dissociated from literary content and worn-out imagery. He achieved this result in a number of ways. He made the students work in unconventional media and he taught them to treat art with a kind of healthy disrespect. Paint was dribbled, sloshed and slapped about. Cement, all kinds of scrap, bottletops, sand, wire—anything that happened to be at hand—would be used. In a series of violent exercises the students were made to 'play themselves free', to lose their inhibitions and gain new vision. Beinart achieved surprising results because his own feverish energy and inspired enthusiasm carried everyone with him into a state of euphoria and creative activity in which people shed all preconceived ideas about art and beauty.

He later used similar blitzkrieg techniques in numerous summer schools in South and East Africa. The impact of this work is difficult to assess, for it is not the work produced during the summer school that matters. Beinart is not interested in getting his students to produce pretty pictures during the short time he is with them. Their picture making is conceived as a series of exercises, a kind of mental limbering-up process that will enable them to create more freely later. It would be fascinating to follow up his students—scattered over the entire continent of Africa—years later and trace the impact of the summer schools. Even then one might not be able to do justice to them. I imagine that often the influence will be indirect. The student himself may be too set in his conventional groove to really become an important artist, but his approach to art teaching will have changed, and consciously or unconsciously he will transmit some of Beinart's ideas to his own students.

Beinart's schools in Ibadan produced some interesting side results which first gave me the idea of organising a different type of summer school in Oshogbo. The atmosphere created by Julian Beinart at Mbari was so infectious that occasional visitors to the club were often drawn in. The best anecdote emerging from the summer schools was that of the car sales-

man who hoped to sell a car to Julian Beinart but who was persuaded to paint some pictures instead. It was interesting to observe the impact the school was having on the fringe students: the caretaker of Mbari, the electrician who had really come to mend a fuse, or the illiterate loafer who had merely been curious. These people were not affected by Beinart's teaching. They did not have enough English to understand what he was saying and they did not *need* his teaching either, because there were no inhibitions to be broken down, no preconceived ideas to be challenged. Entirely unaffected by the intellectual exercises that went on around them, they began to make pictures, and the freshness and charm of their imagery immediately stood out and the directness and sureness of touch was often surprising.

It seemed a worthwhile idea to try to run a summer school especially directed towards this type of student. But the Mbari Club in Ibadan, working in conjunction with the University of Ibadan, was no longer the right channel. A university advertisement would invariably attract teachers and secondary school leavers. At Mbari Mbayo in Oshogbo, on the other hand, we drew our students from a different social class. We aimed at primary school leavers or illiterate people and we did not advertise in the press but through handbills and by word of mouth. In this way we got a less sophisticated but more imaginative crowd and since they all lived in Oshogbo itself there was at least a possibility of a follow-up.

Dennis Williams was invited to run the first of these Oshogbo schools in August 1962, following closely on the second Ibadan school. Most of the students who came were primary school leavers, all jobless, one was a child, and one a professional signwriter. Dennis Williams did not worry these students with any theory or analysis. Beinart's shock tactics, evolved to deal with middle class complacency, were obviously pointless in this setting. Once a kind of enthusiasm was created, the images began to pour out. The time allowed for the course was not even enough to bother much about techniques. The crudest and cheapest medium was used: emulsion paint on hardboard. The delicate job of the teacher was to move the student in the right direction by a careful selection process. Each student produced three or four paintings a day, from which the best were selected every evening and hung till the next evening. By selecting the stronger images, the more honest pictures, and discarding the ones that were derivative or borrowed, the teacher could give direction to the work. In a nutshell, we had sparked the inter-reaction between the artist

and society. In planning the approach with Dennis Williams we thought that if artists degenerate when their only clients are undiscerning tourists, it ought to be equally possible to stimulate a creative approach by supplying a critical audience. Dennis Williams's summer school was rather like a concentrated dose of Frank McEwen's technique in Salisbury, though at that time we knew little about the developments in Rhodesia.

The work produced in this first summer school was more than encouraging. It was interesting to see that even though Yoruba folklore often supplied the theme of the painting the work owed nothing to Yoruba tradition, showed no influence of more recent forms of Yoruba folk art and was not derived from European advertising or illustration with which the students had been in contact. The approach was fresh and personal, about six of the students seemed born painters, and four continued to work for several months after the school. The reason why only one of them, Jacob Afolabi, became a professional painter, may be that we had not given sufficient thought to the necessary follow-up. Dennis Williams lived in Ibadan, sixty miles away, and being busy on research could not find a great deal of time to come and see his painters in Oshogbo. There was also the financial problem of supplying these painters with materials and a livelihood until they were ready to sell. I was able to supply the materials but felt unable to cope with the second problem at the time. So gradually the painters drifted away and only Afolabi remained because he was an actor in Duro Ladipo's theatre company and therefore had a small income. On the evidence of the work produced at this school Afolabi was also the most gifted of the group.

Dennis Williams ran a second school in the following year from which a second artist emerged: Rufus Ogundele, also then an actor in Ladipo's company. At this stage we were better organised to deal with the problem of a follow-up. Georgina Beier had now moved to Oshogbo and kept a permanent workshop open for Afolabi and Ogundele. Having established their talent and roused their interest the problem was now to introduce them to more subtle techniques, to develop their critical faculties without losing the spontaneity of their imagery. In August 1964 a third summer school was conducted by Georgina Beier, this time already with the mature participation of Ogundele and Afolabi, two nearly established artists who were just beginning to make their first sales.

This school produced another four artists: Twins Seven-Seven, Muraina Oyelami, Adebisi Fabunmi and Jimoh

Buraimoh. For the next three years Georgina Beier ran a workshop in her house and the six artists worked there daily. Those who were not members of the theatre company had to be maintained for some time and soon there was the important problem of marketing their work. The most sophisticated artist cannot survive in isolation. In so far as art is communication the artist must seek an audience, he must react to society, even if his reaction is hostile. Recent artistic movements in Europe have been revolutionary, challenging accepted traditions and values not only of art but also of society. In Africa the present generation of artists feels, consciously or unconsciously, that the destruction of traditional values has been carried out by others, by foreigners, and the artist sees his own task as one of reconstruction and rehabilitation.

The intellectual, university-trained Nigerian artist is chiefly concerned with establishing a new identity, with gathering the broken pieces of a tradition and building them—often self-consciously—into a new kind of collage in which the African renaissance is proclaimed. His problem is that he has to proclaim it to the European audience, that he establishes his newly gained identity in the art galleries of Europe more often than in the villages of Nigeria.

The situation of the Oshogbo artists was different. They had never received enough education to become *oyimbo dudu* or black Europeans, as the Nigerian graduate is sometimes called in his home village. They had never left Oshogbo to seek wisdom or skill outside. They had grown up with the festivals of Oshun and Shango and Ogun. Some of their relatives practised traditional religion, others were Christians or Muslims. They had come to accept the juxtaposition of different cultures in their community as a matter of fact. They knew Yoruba tradition, but were no longer part of it. They knew a little about life in the big cities but had no access to it. They were intelligent and imaginative but their school education had not qualified them to become anything—they were not employable as clerks and most of them felt hopelessly frustrated. Both the theatre and the art school of Oshogbo drew on this class of young men and women and to create any kind of opening and outlet for their imagination was like releasing the catch of a spring.

They took a remarkably short time to develop into sophisticated and sometimes mature artists, but the problem was how to preserve them from a tourist market, how to retain the inspiration they could draw from their own environment and how to develop their talent within the framework of their own

society. This is precisely where the existence of the Mbari Mbayo Club proved to be so important. There a local audience had been created. Oshogbo market women may not be good critics of Nigerian painting, but they are prepared to go and see the works. They will talk about them and laugh, they will ask questions and will fondle or slap pieces of sculpture. They were hardly clients, but they were lively participants. In the end it was this local participation that made it possible to obtain local commissions: murals in palaces of Yoruba kings, decoration of an Esso petrol station opposite the Mbari Mbayo Club, church doors and theatre sets. Firmly rooted in such local activity, the artists could sell to European collectors and could work for exhibitions abroad without losing their bearings.

Georgina Beier's four years in Oshogbo probably represent one of the closest examples of co-operation between a European and African artists. She has always refused to be called a 'teacher' because what she was aiming at was in fact a working community in which artists stimulate and criticise each other and she always maintained that she gained at least as much as she gave. Remembering the actual summer school that sparked off the whole development she wrote:

'The summer school opened at 8 a.m. and by lunch time one was already overwhelmed by the swarming talents—ideas as numerous as leaves on a tree. The immediate problem was to recognise each person's individual possibilities at the earliest stage and confirm them in his own direction. The most incredible thing about it was that these young men wandered into the summer school with no particular purpose —perhaps mostly because it was free and they had nothing else to do. None of them was there because he had the urgent impulse to become a painter; yet not a single dull picture was created. Everybody put down confident images with sure strokes. Composition and colour sense came naturally to them. It was difficult to sift the richer from the rich, the stronger from the strong. At first I was worried that a "style" might develop, and everybody might turn out the same stuff in the end. But there was in fact too much individuality from the start.'

When the school ended, no regular workshop was planned, but the four best artists were encouraged to continue their work and materials were provided. Soon it became clear that Seven-Seven's sensitivity to line might best find expression in etching; that Muraina Oyelami badly needed the subtlety and richness of oil paint, as he struggled in vain with emulsion

colours to achieve the lightness and transparency which only oil can give. Adebisi Fabunmi, far more interested in composition than colour, could naturally establish his personality in lino-cuts. Soon the workshop became a full-time occupation for everyone. The main benefit the Yoruba artists derived from the presence of a European artist was simply that they had an additional outside point of view and that they could be shown new techniques when they needed them. No technique was introduced for its own sake. A new technique was suggested only at a stage when it would establish the artist's imagery more firmly. Very soon a hothouse of confident raw material had become a group of conscious, thoughtful painters, who could then go their own different ways. They had found their direction just as Georgina Beier had found her own artistic direction in the process. Work produced by these artists since we left Oshogbo owes much to the fact that it was unpremeditated and that one had no time even to conceive theories or formulas that could have been imposed on the artists. The young artists certainly contributed enough initiative and imagination to prevent the workshop from ever degenerating into a formal 'school'.

52 Twins Seven-Seven
The Devil's Dog (Oshogbo,
Nigeria), 1966. Pen and
ink and gouache.

8 New images

The best-known character in the Oshogbo group of painters is **Twins Seven-Seven**. The name he invented for himself is as bizarre as the clothes he designs and the pictures he paints. To explain the name he produces a variety of stories according to his mood. Sometimes we hear that his mother lost six pairs of twins, and that he is the survivor of the seventh pair. On another occasion we might be told that his mother ignored the custom requiring a Yoruba woman to go begging with her newly born twins, and that as a result his twin brother died in the seventh week.

Seven-Seven appeared one night at a dance held at the Mbari Mbayo Club. His appearance fascinated us at once: a blouse of rather bright Nigerian cloth which had 'Seven-Seven' embroidered across the back, narrow trousers with pink buttons sewn along the seams, zigzag edges cut into sleeves and trousers, pointed Cuban-heel shoes and an embroidered, tasseled cap. Even in a colourful town like Oshogbo he caused a minor sensation. But his dancing was even more exciting than his appearance: his imaginative variations on accepted highlife dancing proved so spectacular that the large crowd cleared the floor for him—a rare happening in a community where nearly everyone is a born dancer. I felt attracted by the young man's personality and was somehow reluctant to let him drift away again. I called him over and asked him what had brought him to Oshogbo. He told me that he had been hired at £3 a month as a dancer to advertise the medicines of a travelling quack doctor. Without having any particular plan in mind I offered a higher salary if he would agree to stay. He asked for a day to think it over and then sent a letter the next day announcing that he would be happy to become my 'backroom boy'.

For a few weeks his main occupation was entertaining the visitors to the Mbari Mbayo Club. Then the third Oshogbo summer school started and Seven-Seven joined, having nothing else to do. From the first minute his talent was distinctive. While everybody was sloshing around with big

brushes on large sheets of paper, he found himself a twig to
draw thin black lines. He was quickly supplied with pen and
ink and soon hit on his characteristic style. His very first
painting, *The Devil's Dog*, already has the typical Seven-
Seven stamp. After the summer school he was introduced to
line etching, which admirably suited his desire to doodle
away in his intricate ornamental manner. After etching some
twenty-four plates he returned to pen and ink drawings,
which he coloured with gouache. As the gouache tended to
swallow the delicate pen and ink patterns he finally varnished
his pictures, which not only gives these paintings a dark icon-
like glow, but also brings out the drawing from underneath
the heavy paint. Seven-Seven's themes are bizarre variations
on Yoruba mythology and legend. They are interpreted by
one who is no longer part of the culture, but who feels he is
being affected and sometimes threatened by the forces he has
not learned to control. The situation is not dissimilar to that

of Malangatana. But whereas Malangatana sees his traditional culture through Christian eyes, and it therefore appears to him as a grotesque nightmare, Seven-Seven merely looks through his own alienated eyes and what he sees is both uncanny and amusing. His great sense of humour is perhaps his most distinctive characteristic. His spirits, ghosts, gods and monsters are never frightening. There is no sense of suffering, no tragic fate as in Malangatana. It is a world of limitless fantasy, of infinite possibilities. His marvellous creatures are truly extraordinary and one can experience something of the lost thrill of one's first encounter with fairy tales: the eye-bodied crocodile, the smallest chicken in the bush of ghosts, and the anti-bird ghost are *real*, not invented. Seven-Seven is no surrealist. He paints the world as he knows it and experiences it, and there is no dividing line in his thinking between the earthly and the supernatural. *The Spectacular Ghost Who Sets Tutuola's Head On Top Of A Coconut Tree* really *exists* and the Baptist Church in the *Twentieth Town of Ghosts* is definitely within our reach. As we wander with him through *Nameless Town* and *Hopeless Town* the very houses begin to live and stare at us from ghost-like eyes. The eye-bodied ghost looks sadly at us through innumerable eyes sprouting from his entire body; the lively ghost, wrestling with a snake, is caught in the swinging pattern of the spider bush; we see the voice of the king in the bush of ghosts—a small replica of the king himself sitting in his throat; Amos Tutuola is transformed into a kind of

54 Twins Seven-Seven
Nameless Town in the Bush of Ghosts (Oshogbo), 1964. Etching.

55 **Twins Seven-Seven**
Amos Tutuola Turned into a Palm Tree (Oshogbo), 1964. Etching.

chimera by the smelly ghost—an uncanny cross between bird, leopard and snake. Decorative pattern is all important in Seven-Seven's work, his sensitivity is expressed in the quivering delicacy of the line itself. Many of his literary ideas seem afterthoughts of design. Even accidental ink blots immediately suggest shapes to him, and shapes suggest stories.

The similarities to the Yoruba novelist Amos Tutuola are striking and result from the fact that both grew up under similar circumstances, in much the same cultural situation, and both were honest enough to present the world as they saw it. Seven-Seven is the ideal illustrator of Tutuola's *Palmwine Drinkard* or *My Life in the Bush of Ghosts* and we did actually ask him to draw some illustrations for the books. Seven-Seven's vision is so clear and so unique that the question of an influence never arose. He does not care very much about other people's pictures and has never derived any inspiration from them, though others have recently begun to copy him.

Seven-Seven's time is still divided between dancing, leading a band, running a small theatre company, and painting. But when he does find time to make pictures, he works easily and fluently and without any soul-searching or technical problems. His early work was 'knitted'—he could start happily in one corner and cover the sheet methodically with his intricate patterns and designs. The composition seemed to 'happen' to the picture. Nowadays he works somewhat consciously and deliberately, starting with an overall design, and on some occasions, when working on plywood, he has even built his stories into the natural pattern of the wood markings.

56 **Twins Seven-Seven**
Priest of Shango, the Yoruba thunder god (Oshogbo), 1966.

116

56

Nevertheless, he is concerned with conveying the story and
with clarifying the imagery rather than abstract problems of
colour, balance, texture or composition. He often sets out to
paint a particular theme but invents the story as he goes along
and is always ready to enlarge on it when requested. Talking
about his pictures, his imagination takes fire to such an extent
that he could, one feels, write an entire novel about each
painting.

Seven-Seven is an artist of unlimited imagination. In his
world everything is possible, many things are worrying, but
most things are simply exciting. The creatures of his mind
seem to proliferate like amoebae, constantly dividing and sub-
dividing themselves into new existences in limitless variation.

Seven-Seven's approach is unique in Oshogbo, where no
two artists really work alike. Perhaps the most complete
contrast to him is **Muraina Oyelami,** a young artist who was
discovered in the same summer school as Seven-Seven.
Oyelami's educational background is similar to that of
Seven-Seven. After primary school he did a further two years

in a 'secondary modern school', but the only job he could find was that of a petrol station attendant. In 1962 he joined Duro Ladipo's theatre company as an actor and drummer. Twice he travelled to Europe with the company, and in 1967 he made a third trip, to accompany another troupe, Theatre Express from Lagos, for their short season at the Traverse Theatre in Edinburgh. For all his lack of formal education Oyelami is a very sophisticated young man. His command of English is surprising and his understanding of Nigerian and world affairs considerable. Unlike Seven-Seven, Oyelami does not work easily. Seven-Seven can work any time in any place, and he can doodle away at his pictures until he gets physically tired. Oyelami needs the right mood and the right surroundings. He cannot simply turn out pictures and often requires days to let an idea mature, finding execution painfully difficult. He does not begin a picture unless he has a very clear idea of what he wants and he will work on it until he feels it is absolutely right. Again unlike Seven-Seven, he will often reject and destroy finished work.

Muraina Oyelami is not usually concerned with Yoruba folklore. His pictures are entitled: *Pregnant Woman*, *Portrait of a Hunchback*, *Psychologist* or *Lovers in a Boat*. His approach is romantic as the pictures suggest, but he is also the only

58 Muraina Oyelami
The Sacred Ram (Oshogbo), 1965. 2 ft. 6 in. × 2 ft. 6 in. Oil.

Oshogbo painter whose work has been influenced by recent tragic events in Nigeria, which have prompted him to paint pictures like *Dead Bodies* or *Deserted City*. The work of Oyelami teaches us to be very careful indeed about generalising on 'African' and 'European' art. Most casual observers would immediately label the surrealist world of Malangatana or the supernatural fantasies of Seven-Seven as 'typically' African, while they might suspect European influence in the sophisticated, abstract work of Oyelami. The fact is, however, that they all have much the same background and the same lack of real European influence.

Oyelami, strangely, began with abstractions. His very first pictures at the summer school were compositions which merely hinted at imagery. His first oil paintings were city pictures, which again were very nearly abstract. Some foreign observers were convinced he had seen books of Paul Klee, but the only European artists he had been in contact with (Georgina Beier and Susanne Wenger) preferred strong imagery to abstraction and art books were simply not available then in Oshogbo. Oyelami was far more interested in the technique of painting than other Nigerian artists. His handling of paint and his sense of colour soon became very subtle. His design is usually simple, and it is the delicate, breathing surface that gives life to his pictures. Like most artists whose work depends largely on texture he does not reproduce well, and even colour reproductions seldom do him justice. Most artists seem to move from figuration to abstraction, but

59 Adebisi Fabunmi
Russian City (Oshogbo), 1966. Lino-cut.

60 Adebisi Fabunmi
Oshogbo, 1966. Lino-cut.

Muraina Oyelami went the other way. From his earlier near-abstract city pictures, he moved on to large, icon-like faces whose religious feeling again made people think of Rouault, even though Rouault was as unknown to him as Klee. Many Oshogbo artists move in a permanent world of fantasy, a world where the activities of the spirits and gods of traditional mythology are as real and present as the quarrelling house-wives next door.

Oyelami's work is always related to actual experience as we know it. Most of his work refers to people he knows or experiences he has had in daily life. Seven-Seven is at heart a storyteller. Oyelami is a poet. He is unable and unwilling to give lengthy explanations of pictures, and feels strongly that his symbols need no literary backing.

At present Oyelami is curator of the antiquities museum in Oshogbo. He shares this job with **Adebisi Fabunmi,** a third painter to emerge from the 1964 summer school. Fabunmi's best works to date are his lino-cuts, in which he seems to combine fantastic content with a highly disciplined sense of form. His most impressive graphic work so far is a series on cities. Whether they represent West African towns like *Lagos* and *Takoradi,* or European cities like *Berlin* and *Russian Town,* or whether they are purely imaginary themes like *Ghost Town* or *The Hanging Gardens of Babylon,* the towns all show a certain family likeness. They are all equally remote from realistic representation. They are complex designs, in which houses, turrets, battlements and other architectural

elements are curiously interwoven with large animals or birds,
looming in the sky, and large, purely abstract shapes that cut
across, divide and pull together the animated design. The
boldness of the cutting, the symbolism, and the strain and
stress pattern of the design give a strong expressionist feeling
to these lino-cuts, not unlike some of the woodcuts of the
Brücke painters early this century.

There is movement in these towns and a strong feeling of
tension, which is all the more uncanny since there are no
people about anywhere. Occasionally a single face crops up,
or a hand or a leg, but on the whole the streets are devoid of
people. Water and sky are always near, making threatening
inroads on the city and above all there are the mystic animals,
sitting or floating like fate over the deserted streets. One of the
pictures is called *Empty Otan*, a reference to a town some
thirty miles from Oshogbo which was partly destroyed and
completely deserted when the riot squad took punitive action
during the political troubles in 1965. Fabunmi himself was
sadly affected by these events because his finest work, a mural
in the king's palace, went up in flames during the disturbances.
Empty Otan is the most dramatic of these designs. The houses
lean over, ready to fall and tumble on top of each other. Yet

61 Adebisi Fabunmi
*The Hanging Gardens
of Babylon* (Oshogbo), 1966.
Lino-cut.

other pictures which have no such direct reference, like *Benin* or *Ibadan*, have the same sense of threatening doom, the same feeling of hopelessness. Sometimes the layers above layers of houses and streets are reminiscent of a cross section through some archaeological mound, revealing successive buried cities, each the silent witness of some past disaster.

Fabunmi's decisive shapes are in strong contrast to the lino-cuts of **Jacob Afolabi**, who was Oshogbo's first real discovery. Afolabi is always concerned with people but he completely overrides all conventional ideas of anatomy. It is not so much a case of the artist deliberately distorting or exaggerating basic forms. Afolabi does not transpose the organic structure. All his shapes are fluid like plasma: joints can appear in the most unlikely places, or can be ignored completely, arms and hands can sprout anywhere from the black body mass, and the head can be connected to the neck anywhere. Looking at these fluid, oozing forms, one feels that these figures have no permanent shape, they seem to change in front of our eyes, to congeal or dissolve. Body masses gather together, then split off again into smaller masses like mercury; feelers are stretched out in different directions, to be

62 Adebisi Fabunmi
Takoradi sea port (Oshogbo), 1966. Lino-cut.

suddenly withdrawn like a snail's horns; coils unwind them-
selves, while other shapes are looped into fresh spirals. Within
the framework of this quivering world, Afolabi tells simple
stories, like *The Installation of a King* or *The Sacrifice of
Abraham*. Even the most straightforward themes like *Acro-
batic Display* acquire a strong surreal significance. Afolabi is
equally a painter of dreamlike pictures and one of his best
known works was a large mural on the Esso petrol station in
Oshogbo.

Afolabi's younger colleague **Rufus Ogundele** began paint-
ing when he was fifteen. The graphic media suited his wilder
temperament less well. He needed oil paint and a large surface
to express himself and his best works are large violent paintings
in which an unbearably intense juxtaposition of yellows, reds
and oranges seems to burst out of the confines of the frame.
His paintings are expressionist explosions, witnesses to the
artist's youthful, aggressive approach to his medium. The
impact of these pictures was refreshing and convincing, and

63 Jacob Afolabi
Untitled (Oshogbo), 1964.
Lino-cut.

64 Jacob Afolabi
Sacrifice of Abraham
(Oshogbo), 1964. Lino-cut.

65 Jacob Afolabi
The People of Odidare
(Oshogbo), 1964. Lino-cut.

64

65

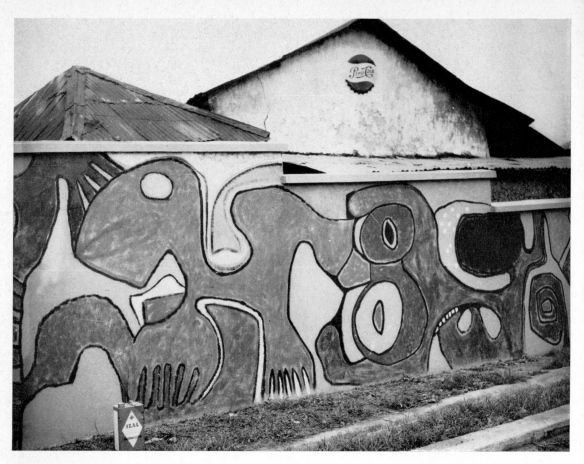

66 Jacob Afolabi
*Mural at Petrol Station in
Oshogbo*, 1966.

67 Rufus Ogundele
*Sacrifice to Ogun, God of
Iron* (Oshogbo), 1965.
4 ft. × 3 ft 6 in. Oil.

68 Rufus Ogundele
*Prayer to Ogun, God of
Iron* (Oshogbo), 1965.
4 ft. × 3 ft. Oil.

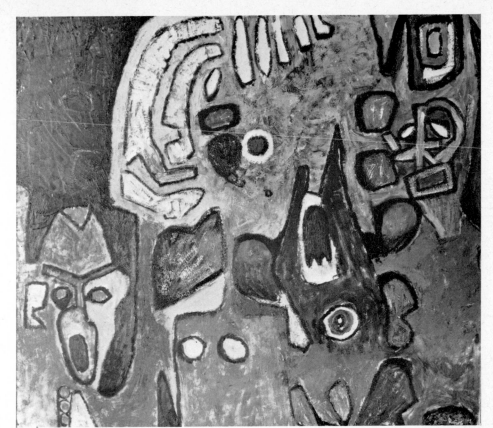

67

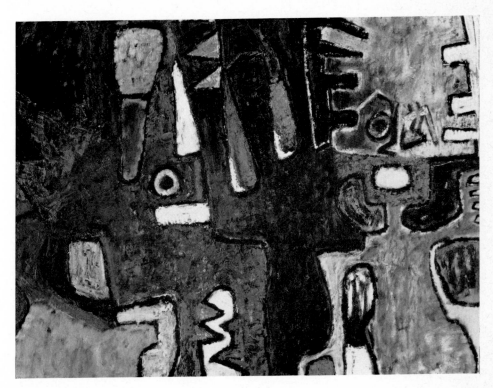

68

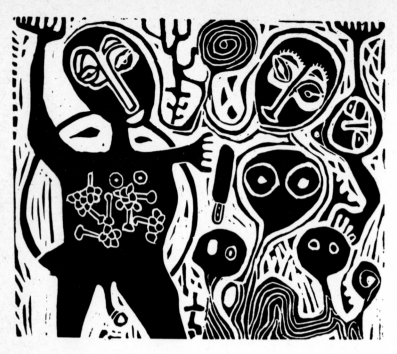

69 Rufus Ogundele
*Scene from the Yoruba
Opera 'Oba Koso'*
(Oshogbo), 1964. Lino-cut.

Ogundele doubtless has an important career as an artist
before him. His extreme youth made it necessary for him to
interrupt his artistic career in order to go back to school and
finish his education. He is the only member of the Oshogbo
group who has had the opportunity to receive a secondary
education and it will be interesting to see what becomes of him
now that he has finished school and is returning to painting.

In addition to these five painters, several other artists who
work in other media must at least be mentioned briefly.
Jimoh Buraimoh began as a painter but finally settled for
mosaic. Buraimoh is an electrician who has become attached
to Ladipo's theatre company for which he does all the stage
lighting. He evolved an attractive technique of laying small
mosaics with strings of local beads. More recently he has
executed some large commissions, working more freely and
building his mosaics from a variety of beads, potsherds,
stones, etc. His imagery is clearly inspired by the Oshogbo
school of painting, but he knows how to exploit his personally
discovered medium to the full and develops many attractive
ideas from his technique. At the time of writing, he seems only
at the beginning of his career. (See colour plates.)

Samuel Ojo, a friend of Seven-Seven and a member of his
theatre group, is working in appliqué. His cut-out and em-
broidered figures are fantastic like Seven-Seven's own inven-
tions, but they are happier, brighter and infinitely gentler.
His own medium is very limited, of course, but within this

framework he has created many images and objects of great charm.

Finally, there is **Jinadu**, who has recently revived the ancient art of brass casting by the *cire perdu* method. He was the last artist to join the group and at the time of writing has only just found his own style. Jinadu started work as an artist late in life. Unlike the artists so far discussed, who are all in their early twenties, Jinadu is in his mid-fifties. He is a senior brother to Asiru Olatunde (see chapter 10) the successful metal relief worker and it was Asiru's unheard of success as an artist that decided Jinadu to try something of his own. Being brought up in a vaguely Muslim family, he finds it impossible to work in the traditional context and unlike Yemi Bisiri (see chapter 1) Jinadu cannot work for the secret Ogboni Society. Jinadu casts bracelets and makes pendants which have recently been adopted by all the Oshogbo artists as a kind of insignia. At the time of writing he has begun to cast figures in brass which are pure art works and are not meant to serve any religious purpose.

The Oshogbo art school was not an aesthetic experiment: it was designed to create a living for these artists and to build up a new function and a new social status for them. All the artists mentioned here can now live off their work. Moreover, their work is not geared to the European collector alone. Though they have exhibited in many European cities (Berlin, Munich, Prague, Amsterdam, London, Edinburgh) their work can also be seen in Oshogbo and its surroundings where they have executed several murals on two palaces, for a petrol station, in the Mbari Club, and elsewhere. More than any other workshop group in Africa, they have become integrated in the local community.

70 Georgina Beier
Mural at Mbari Gallery
(Lagos).

9 Metamorphosis

In Lourenço Marques, Salisbury and Oshogbo, as we have seen, the meeting of European and African artists sparked off new creative activity and new 'schools' of painting, if not movements. The process can be seen as a kind of reversal of the stimulus that went out from Africa around 1906–1907 when Vlaminck, Derain and Picasso 'discovered' African sculpture and derived entirely new ideas from the encounter. It is possible to distinguish some general characteristics that the Lourenço Marques, Salisbury and Oshogbo schools have in common. It would be a mistake to put this down simply to foreign ideas being adopted or accepted indiscriminately. An artist can only digest congenial material. African wood-carvings, for example, were seen by *many* European artists, but only a handful responded to the stimulus and were enriched by the experience. Similarly, it is a certain type of African talent that is attracted to a certain type of foreign stimulus. A European artist, living or working in an African town, will respond to certain artists, but will fail to create an ambiance with others. Thus the different schools or movements are *related* to the personality of the artist who served as the catalyst, but they were not *made* by him.

Oshogbo offers a very interesting example of this because two European artists were at work simultaneously, gathering different sets of local artists and each producing an entirely different type of impact. While Georgina Beier worked through summer schools and workshops and dealt mainly with the social class that drifts aimlessly between two worlds, Susanne Wenger was mainly concerned with the ancient traditional culture of the Yorubas and with its last exponents.

Much has been written about the Austrian painter who came to Nigeria in 1950 and became so integrated into Yoruba life that she was made a priestess of Obatala, the Yoruba creator god. The theme of the 'white priestess', the intellectual European 'gone native' lends itself only too well to sensational journalism. Since independence in 1960 both Africans and Europeans in Nigeria have become used to rather more

L

normal relationships. The Peace Corps can actually be seen walking on foot in an African town or even eating 'native' food, palm oil, pepper and all. In 1950, even a European on a bicycle caused a minor sensation. As for a woman taking part in a pagan religious ceremony, it was considered to be an absolute scandal, an extreme case of 'letting down one's skin', to use the grotesque colonial-racialist phrase that was commonly heard in those days. The early attitude of Europeans to Susanne Wenger really tells us much about the deep prejudice that still prevails about African cultures. Europeans who become Muslims or identify themselves with Buddhist or Hindu ways of life are considered romantic, but living with primitive 'savages' is either dangerous or mad.

Prejudice against African beliefs and practices has died hard, even though Frobenius believed he had discovered the lost Atlantis in Yorubaland in 1910 and many accounts and interpretations of this complex culture have been written since. The attraction of Yoruba life is considerable for any person who still wishes to interpret the world in religious terms, but who can no longer accept Christianity in a world where the churches seem to avoid many burning issues and living symbols have often been turned into dry formulas. Moreover, the rationalism of Protestant Christianity that has led some European intellectuals back to Catholicism could equally lead one towards Yoruba symbolism.

For a European artist who had been interested in religious symbols all her life, the attraction is perfectly obvious. In Europe symbols have been relegated to dreams, fairy tales and the writings of psycho-analysts, but here suddenly was a culture in which they had to be lived. The deity does not exist *as such* but through the living manifestation of its worshippers. Relationships between gods and men are not laid down in a rigid codex of laws and taboos but have to be re-established daily through divination and sacrifice, both of which involve constant soul-searching. The gods are no more predictable than men, and their power and their beneficial influence depend entirely on the harmonious relationship one has been able to establish. The multiplicity of gods is simply a way of acknowledging the diversity and complexity of human minds and the need for varying approaches to the ultimate truth and to the absolute deity. In classical Greece the Olympic pantheon had been relegated to literature and the amorous exploits of the gods were considered entertaining, but many thinking men considered them archaic symbols of the past that had no bearing on the needs

71 Georgina Beier
Mural at Mbari Gallery
(Lagos).

of the present. In Yoruba religion today a continuous process of reinterpretation is possible because the personalities of the gods are not so much laid down in an organised cosmology as they are found in a loose conglomeration of praise names, which are constantly rearranged and added to according to the changing mood of the praise singers and the aspects of the gods' characters being emphasised by the priests. It is significant that in Yoruba the expression 'to worship a god' could also mean to 'make a god'. In such a situation it obviously becomes rather pointless to ask Susanne Wenger why she was 'converted to paganism'. It is clearly not a question of abjuring one set of beliefs and taking an oath on another lot. It is a matter of participating in a search for truth with people and in a community which does not believe that it has found the absolute and permanent answer to the important questions.

Susanne Wenger believes that once you penetrate the trappings of ritual, mythology and tradition the truths offered by different religions lie very close together. To exchange

Christian mythology for Yoruba mythology is rather like continuing to speak about the same subject in another language. The very fact that the language is unfamiliar forces one to express oneself more clearly. One is compelled to search for the right word all the time, whereas in one's own language the temptation is great to use words loosely and to accept woolly and worn-out phrases. Susanne Wenger accepts the fact that she cannot identify herself fully with her Yoruba friends. She knows that she has possibilities of comparison and a breadth of horizon which they cannot share. On the other hand they have an experience in depth to which her own cultural background has no equivalent. But then the very nature of Yoruba religion makes divergent interpretations possible, even desirable, and she has reason to believe that her own approach helps to revitalise a culture that is threatened on all sides by economic, political and religious solvents.

History will no doubt take its course and it may be unlikely that in a few generations from now Yoruba religion will still be practised to any large extent in Nigeria. However, it is a very flexible and adaptable culture and just as certain syncretised

73

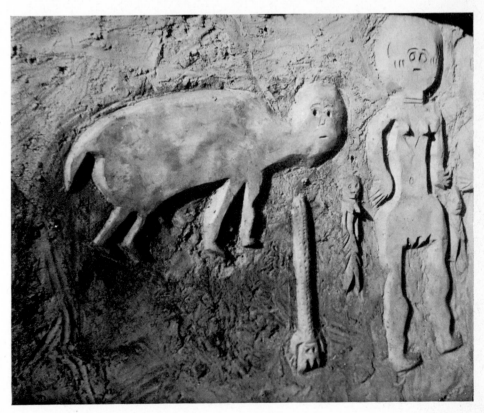

74

forms have survived in Cuba and Brazil, it is also possible that Nigeria will develop new forms of religious and artistic expression that owe much to this tradition. At the moment one can certainly speak of the renewal of Yoruba culture in Oshogbo, and some thirty-odd years after the last wood carvers were inspired by Oshun, Obatala, Shango and all the other Yoruba gods, shrines are being rebuilt in the forest, new statues are dedicated to the gods, and festivals are being revived. The impact of this extraordinary activity can be measured by a number of different yardsticks. Some sceptics will say that this is merely a flash in the pan, that this culture is doomed in any case and that a few years of 'revivalist' activity will make no difference either way. Against this it can be argued first of all that a work of art is finally judged by its viability as a work of art and not by the validity of the philosophy that inspired it or even by the current importance of such a philosophy. Seen in these terms, Susanne Wenger's own works must be considered an important contribution to artistic life in Africa. It is idle speculation to try to assess to what extent these works are 'European' and to what extent they can be called 'African'. It is difficult or impossible to think of Oshogbo without their continuous and inspiring presence. A second way of assessing Susanne Wenger's impact is to judge the direct stimulus her work has given to a number of local artists, several cement sculptors and one wood carver, who form as it were her 'school' and whose work she has used extensively in the shrines and monuments she has erected in Oshogbo.

Finally there is an important indirect influence. The prestige she has been able to give to Yoruba culture and religion has liberated many artists whose main concern is not with religion. The Yoruba theatre in Oshogbo could not have dealt so freely and understandingly with traditional themes and could not have found such a willing audience if some of these ideas had not acquired a genuine new life in the town. In much modern African art traditional beliefs and ideas have been distorted into witchcraft fantasies. Oshogbo is one of the few centres where African religion is considered by the artists to be a valid philosophy and way of life.

Susanne Wenger went to Nigeria without any preconceived ideas. At no stage did she try to teach or to exercise any kind of influence. She is a person who will always allow infinite time for things to mature; she will never try to precipitate events. For some time she continued to do oil painting in Nigeria, though her themes and technique changed. After

75 Other details from *Wall* shown in Plate 72.

about four years of growing involvement, she began to feel that this technique was artificial, that she lived in a community where an artist could not lock himself up in a studio to give birth to a painting which would then have to be sent abroad to be appreciated. An immediate solution was to adopt the Yoruba batik technique.

The method of *adire*, as the Yorubas call it, consists of painting a design on cloth with liquid starch. The starch acts as a resist when the cloth is dyed in indigo and the design then appears in white lines on a deep blue background. The Yorubas use this technique to produce women's wrappers of more or less geometrical design. Susanne Wenger produced large wall hangings in which she told the stories of the Yoruba gods. Her angular, dramatic figures re-enacted the ancient tales on cloth. Her own versions of the myths were free elaborations and she never hesitated to allude to similarities between, say, the imprisonment of Obatala, the Yoruba creator god, and the passion of Christ. She has always considered symbols to be universal and her *adire* cloths allow numerous and different interpretations.

Through exhibitions in Paris, London and Frankfurt these batiks achieved some publicity in Europe. But Susanne Wenger achieved fulfilment as an artist only when, in recent years, her social position in Oshogbo had become so important that she could undertake the reconstruction of the neglected shrines and holy places in the town. In this respect Oshogbo has become a unique place in Africa. Nearly everywhere the

76 Ojewale and **Lani**
Cement relief from the monument to Ogun Timohin, the first hunter who lived on the site of the present Oshogbo, 1964.

sacred buildings are crumbling, sacred groves are cut down for timber, petrol stations rise on historic and religious sites. In Oshogbo the process has been arrested: the sacred grove of Oshun has been declared a national monument. The town council—so far the only one in Nigeria—has voted money for the maintenance and restoration of ancient shrines. Contributions have come from outside and Susanne Wenger has spent most of her income from the sale of pictures or batiks on the work of reconstruction.

Her first important reconstruction work was the temple of the goddess Oshun, by the river bank where the annual town festival takes place. This shrine was more or less intact and merely needed repair. Susanne Wenger employed a couple of bricklayers to carry out this work. As they were rebuilding the long wall that shields the sacred grove from the rest of the forest, the two bricklayers suddenly felt strangely inspired. They began to make one or two little reliefs in cement in some rather inconspicuous places, depicting spirits and forest gods. Susanne Wenger immediately encouraged this: she bought more cement and invited the two bricklayers—Ojewale and Lani—to continue with this work and to decorate the entire wall. The results were figures of childlike simplicity, yet of almost unlimited invention. The long frieze of figures has the effect of a sudden glimpse into the mysterious world which only the heightened state of trance would

ordinarily make accessible: mythical creatures, some multi-headed, others feathered and winged, all vaguely human, populate the wall. A powerful feeling of supernatural presence descends on the visitor approaching the wall. Even the sceptical Westerner cannot ward off a certain feeling of awe.

Purist anthropologists have criticised Susanne Wenger for allowing this to happen. The wall—they argue—was blank before and should have been rebuilt as it was. And in any case, the cement figures differ fundamentally from the traditional Yoruba sculpture and are therefore seen as a 'foreign' element in this context. This attitude is typical of the more desiccated school of anthropology that does not study human societies as living and changing organisms, but believes that in order to study a 'primitive' culture successfully one must try to 'preserve laboratory conditions'. Susanne Wenger, on the other hand, sees Yoruba religion as a living philosophy and she is fully aware that it cannot be the same in 1960 as it was in 1900. The worshipper of the river goddess Oshun is aware of too many changes and too many alternative ways of living today. The purity and discipline of traditional Yoruba

77 Adebisi Akanji
Entrance gate to the Oshun grove (Oshogbo), 1966.

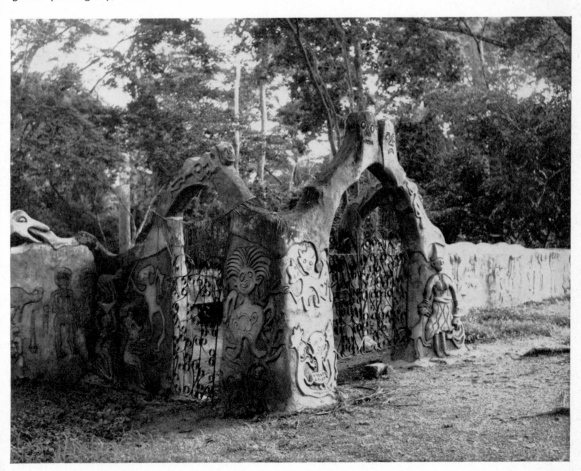

78 Adebisi Akanji
Detail of Plate 77, two
people playing *ayo,* a kind of
African draught game, 1966.

sculpture is hardly possible for young artists of today. Tradi-
tional art has arrived at a kind of dead end and new interpre-
tations can only come from a different social class. The brick-
layers were people who had already chosen a new profession
and were working in a new medium, even though they were
illiterate and had not enjoyed the benefits of any Western
schooling. Emotionally they were still attached to Yoruba
beliefs, though they were nominal Muslims. Unlike their more
orthodox brothers they have not resigned themselves to the
fact that they are the last generation of a thousand-year-old
culture. They took up the challenge and had the vitality
and the aggressiveness needed to manifest their faith in
Yoruba ideas in a hostile modern world. They had no inten-
tion of becoming artists. They were builders, employed to do
a job, and suddenly found that the awe-inspiring atmosphere
of the sacred grove and the personality of Susanne Wenger

carried them away over unexpected horizons. The reliefs they
created bear no resemblance to traditional religious carving.
The old art was austere, static, powerful, conventional. Theirs
is vivid, full of movement, fluid and individual. The brick-
layer artists Ojewale and Lani left behind a great monu-
ment of contemporary Nigerian art before they drifted back
into the routine of their profession and into the violence of
Nigerian politics in which they were both deeply involved.

Susanne Wenger has since been working on her projects
with another bricklayer-sculptor, Adebisi Akanji, who created
the magnificent entrance gate to the Oshun grove. His work
has such a wide range and is so individual that we shall
discuss it in more detail in the next chapter. Susanne
Wenger followed up the restoration of the Oshun shrine with
several other big projects. First the temple of Alajire, the
Yoruba god of suffering, was rebuilt on the ancient site. Only
a few ruined walls had remained and Susanne Wenger felt
free to rebuild it in her own style. Surrounding the shrine in
the forest are cement sculptures representing the pantheon of
Yoruba gods. Her most mature works, however, are the most
recent buildings: the temple of Obatala, the creator god, and
of Busayin, a very old site for the worship of Oshun. She
believed rightly that her vast undertaking could only become

alive if she interpreted the religion in her own light, rather
than attempt slavishly to reproduce traditional forms of
architecture. She felt sufficiently in sympathy with the
religion and sufficiently integrated into the society to be
entitled to do so. In any case she did accept certain basic
concepts of Yoruba mud architecture: that a building must
rise from the ground like a tree, that it must grow from
the soil, not stand on it, that the forms must blend with the
forest, and that the surface should preserve a feeling of the
human hand. She simply carried these basic concepts to their
logical conclusion. Her new buildings thus became large
breathing sculptures through which one walks, fantastic
growths in the forest like exuberant plants. The result is
strangely reminiscent of Gaudi, but only because both artists
treat architecture as sculpture and insist on using the same
freedom of invention that a painter or a sculptor has. The
important difference in approach is that whereas Gaudi
merely expresses his personal *joie de vivre* in his buildings,
Susanne Wenger's mud architecture must be in tune with a

81 Susanne Wenger
Temple of Obatala, the
creator god in Oshogbo,
1966.

whole culture and a philosophy. They must be Yoruba
architecture as well as Susanne Wenger's architecture. Apart
from their intrinsic value as works of art these mud shrines
have a twofold importance: they prove that Yoruba religion
is still sufficiently vital to inspire modern works of art, and
they arraign the ruthless brutality with which most European
architecture imposes itself on the landscape, peoples and
cultures of Africa.

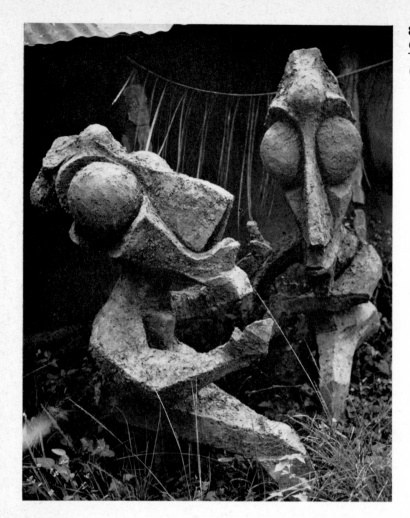

82 Susanne Wenger
Cement sculpture at the
Temple of Obatala
(Oshogbo), 1966. 4 ft. 6 in.

A discussion of Susanne Wenger's activity in Oshogbo must include a remarkable wood carver, **Buraimoh Gbadamosi**. It will be observed that nearly all the artists of Oshogbo are working in new media: painting, the graphic arts, cement sculpture, mosaic, metal relief. As elsewhere in West Africa, the tradition of wood carving was so powerful there that a modern artist finds it difficult to express himself in this medium. The burden of history, convention and associations weighing on this traditional art form is suffocating.

Buraimoh Gbadamosi was born in Oshogbo some thirty years ago. He comes from a Muslim family that never produced artists in the past. Buraimoh became a carpenter, but he was a bad carpenter and earned little money. The mere accident of living next door to her brought him into contact with Susanne Wenger. At first he attended her religious ceremonies as a drummer—perhaps to earn a few extra shillings. But soon he joined the growing community of those Yorubas who took another look at their tradition and suddenly

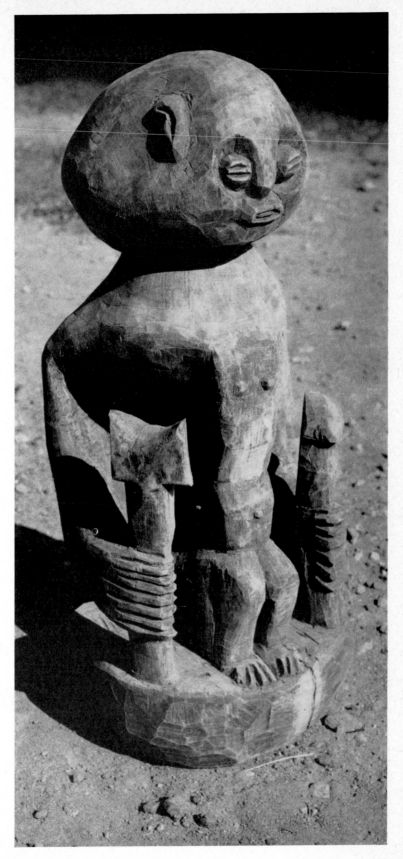

83 Buraimoh Gbadamosi
Wood carving representing a
Shango priest (Oshogbo),
1966. 2 ft.

discovered that these ideas meant more to them than they had expected. A nominal Muslim like Buraimoh Gbadamosi would have avoided any association with traditional religion for fear of being called 'backward' or an 'idol worshipper', but the new prestige given to this way of life by Susanne Wenger gave him courage and he found that it excited him far more than the prohibitive, formalistic Muslim religion. Without ever officially ceasing to be a Muslim he got more and more involved in the festivals of the Yoruba gods and he longed to give artistic expression to his experiences. At first he started to carve relief doors, and he could not find his way to sculpture in the round for a long time. His early work was clumsy and childish but for some reason or other, Susanne Wenger was convinced from the start that he was going to become an artist. However, she gave him time, she never pushed him, never taught him, simply allowed the situation to ripen. The breakthrough came suddenly. One day he called us to his studio and there, to our surprise, were these little figures: dreamy men and women, their heads gently inclined, introvert religious art that might have been created generations ago.

A closer look at these sculptures shows that he has borrowed nothing from Yoruba tradition. Yoruba religious carving was organic, was based on anatomical forms which were modified and distorted according to a strict convention. A Yoruba carving emphasised such features as eyelashes, cheekbones, nostrils, tribal marks and pubic hair, all absent in Buraimoh Gbadamosi's much more simplified forms. Gbadamosi's faces are reduced to the simplest formula; they are carved deep into the spherical head. Whereas traditional Yoruba carvings always represented female breasts as full, pendulous and pointed, symbols of fertility, Gbadamosi gives them a very varied treatment: sometimes he shows the limp breasts of an old woman, sometimes he represents the undeveloped points of a very young girl, once he even carved a woman with four breasts. Gbadamosi's approach is expressionist—to convey the physical power of a warrior he can give the figure an absurdly exaggerated shoulder line and the hand gripping the insignia of office has eight fingers; a pregnant woman is nearly weighed to the ground by her belly, which threatens to topple the whole of her body.

Traditional Yoruba sculpture was always static, the ancient carvers present the front, back and two sides of a figure, which rested equally and solidly on both feet. Buraimoh Gbadamosi introduces a slightly sentimental tilt of the head,

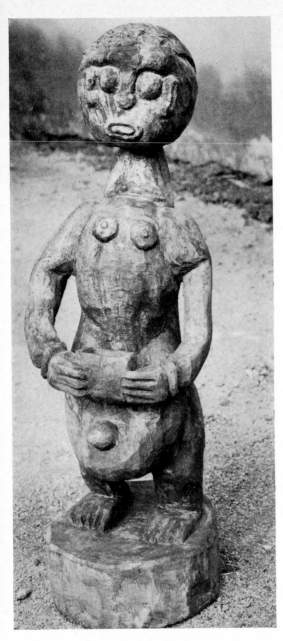
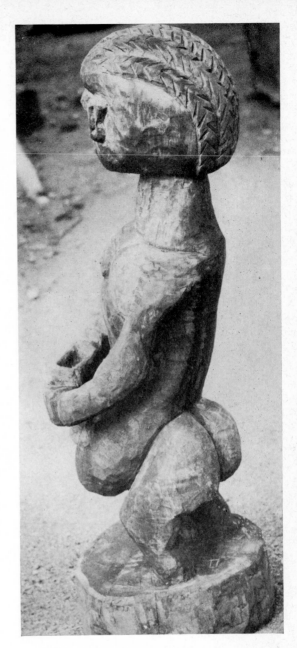

84 Buraimoh Gbadamosi
Wood carving (Oshogbo).
This carving of a pregnant
woman is 3 ft. high.

M

he twists the body axis, and sends a tense, snakelike movement from the right shoulder down into the pregnant belly of his figure. These are new ideas, new sculptural concepts that grow from a contemporary interpretation of Yoruba religion. Traditional Yoruba wood carving degenerated into a feeble washed out 'survival' because the artists stuck slavishly to a convention that had grown from a philosophy which they no longer believed in. For hundreds of years these carvers had been in tune with their community and had successfully expressed the moral and aesthetic values that were accepted by all. When the society went through a crisis in which every single value was challenged the traditional artists found no answer to this challenge, but simply continued to repeat their convention until it became an empty phrase. It was left to people from a different background, people like Buraimoh Gbadamosi with no artistic tradition in the family, or to complete outsiders like Susanne Wenger, to make a new and valid statement about the Yoruba way of life.

10 Beyond folk art

The two previous chapters described two parallel develop-
ments in Oshogbo art. We should not see them as entirely
separate, or even as rival movements. All the artists know each
other and are interested in one another's work and cross
influences are numerous. At the time of writing Susanne
Wenger is conducting the fourth Oshogbo summer school,
thus working with a different type of artist. Two of Oshogbo's
most important and best known artists have received stimuli
from both groups of artists and could be said to form the link
between them. One of them is the cement sculptor Adebisi
Akanji, the other the metal worker Asiru Olatunde.

Adebisi Akanji is now in his early thirties. Five years ago
he was a bricklayer with no artistic ambitions. He owes his
'discovery' to an interesting circumstance. In 1962 I was
organising an exhibition of Nigerian Folk Art for the Mbari
Club in Ibadan. I was anxious to include some cement lions
from the 'Brazilian' style Yoruba houses built in the thirties
and forties. The lions were playful variations on Portuguese
heraldic sculpture, of which a few examples had been imported
by repatriated slaves from Brazil in the late nineteenth
century. Illiterate builders started to imitate the baroque villas
these Brazilians had erected in Lagos, and they threw in some
fanciful cement sculpture for good measure. The respectable
fifties had seen the end of this imaginative style of architecture
and with it the sculpture also faded away. The bourgeois
breeze block houses had no room for funny lions. Though I
was anxious to have such works in my exhibition, I was
reluctant to buy them off people's houses, leaving their
balconies bare. In the end I gathered some young Oshogbo
bricklayers and asked them whether they could make some
new ones. None of these young men had ever had such a
commission before but most of them had a go and the results
were very charming. It seemed a pity that all this talent should
go to waste again. I selected the best of the bricklayers,
Adebisi Akanji, and invited him to work for a special exhibi-
tion in Oshogbo in which nothing but his own work would be

85 *Cement Lion* from a Portuguese-style house in Lalupon, Western Nigeria, around 1945. 18 in.

shown. He produced a dozen brightly coloured cement figures representing all kinds of animals and people. We sold a few of these to the staff of Ibadan University who wanted them for their gardens. Adebisi's talent was clearly established by now but the problem was how to find sufficient commissions to give him a living and how to make these commissions sufficiently interesting to help him develop as an artist. It was when we set up the Oshogbo museum of popular art that we suddenly hit upon the answer. We asked Adebisi to construct a cement screen to shade the entrance to the museum, built up from his popular animal shapes. Adebisi produced a most impressive composition immediately transcending the scope of the folk art which he had originally revived. The new technique he developed and the freshness of his ideas in this screen opened up an entirely new career. Here was a new medium that could easily be used in architecture. Above all there was considerable scope for selling this work locally and one had averted the danger that Adebisi would become a producer of garden toys for intellectuals in Ibadan. His next big commission was the palace of Otan, for which he made a magnificent screen and where he co-operated with some of the Oshogbo painters in redecorating the entire building. More recently he has co-operated with Susanne Wenger on some of her most ambitious schemes and has produced relief sculpture and an entrance gate at the sacred grove of Oshun. His most popular and conspicuous work is the Esso petrol station in Oshogbo which is situated opposite the Mbari Mbayo Club. He built cement screens all round the hideous little glass hut

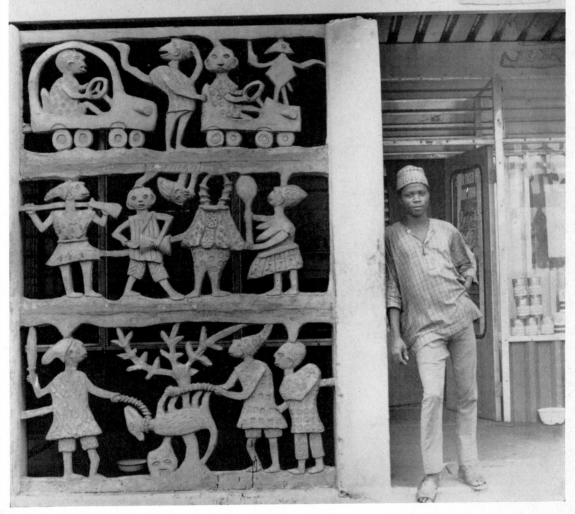

86 Adebisi Akanji
*Screen at Esso Petrol
Station* in Oshogbo, 1966.
Cement.

Top: cars taking petrol.
Centre: hunter, drummer,
Egungun masquerader,
female Shango worshipper.
Bottom: sacrifice of a dog to
Ogun, God of Iron.

87 Detail of Petrol Station Screen, Plate 86.

88 Detail of Petrol Station Screen, Plate 86.

89 Detail of Petrol Station Screen, Plate 86. Leopard, snake, crab and imaginary animals.

which is the petrol firms' standard design for Nigeria. On it he depicts a lively imaginary world of extraordinary contrasts which is so typical of Nigeria today.

Little men ride around in toy cars. Some drink palm wine and laugh. Drummers play as dignified Yoruba chiefs dance. Lions smile innocently. Strange creatures, from a medieval bestiary perhaps, stretch their decorative limbs. It all adds up to a dream in cement, a crazy petrol station, a work of art that is typically Yoruba and characteristic of the essential Oshogbo. Everyday life and fantasy form one and the same

153

world. The old and the new, motor cars and masqueraders, live side by side without tension. Adebisi's art is powerful and playful at the same time, a typically Yoruba synthesis, one in which the serious and comic aspects of life present themselves as an inseparable whole. The conflict of cultures has created schizophrenic tensions among some African communities. Among the Yoruba it has led to that happy confusion, that abandoned extravagance which is so perfectly illustrated in the work of Adebisi Akanji.

The story of **Asiru Olatunde** is similar. He too owed his discovery to a strange accident. One day in 1961 a small copper ear-ring was found in the street outside our house. It was a tiny lion cut from copper sheeting and with a few lines scratched in to suggest eyes, mane and smiling mouth. It was nothing really exciting but had a certain charm and one was naturally curious to know where it came from. In the end we were told it was the work of Asiru Olatunde, who was living opposite and was well known to us as a neighbour but not as an artist. He was in his mid-forties and belonged to a family

90 Detail of Petrol Station Screen, Plate 86. Drinkers, dancers, and drummers.

of blacksmiths. Bad health had prevented him from continuing with the family craft. Some twenty years earlier he had thought of making little ear-rings from copper and for a while it brought in some money. But soon he was unable to compete with the trashy imported trinkets that were sold in the market for as little as 3d (3 cents) a pair. Thrown out of work a second time he gave up and gradually accumulated debts. The chance discovery of the ear-ring opened up a new career. It was easy to sell such things to friends at the University of Ibadan. We encouraged Asiru to resume work. So far we did not visualise him as an artist but merely as a craftsman whom one could help earn a living.

When our friends were all supplied with ear-rings, we had to think of something else. Asiru then made bracelets and brooches but the market for these was quite limited. Asiru

91 Adebisi Akanji
Cement wall from Mbari Mbayo Art Gallery in Lagos. *At the bottom*: 'Oba Kabiesio' is the traditional greeting for a king: *long live the king*. The king here is Shango, ruler of Oyo who hanged himself, was deified and became god of thunder. *Top*: 'Oba so'— *the king hangs*, shows the death of Shango. 1965.

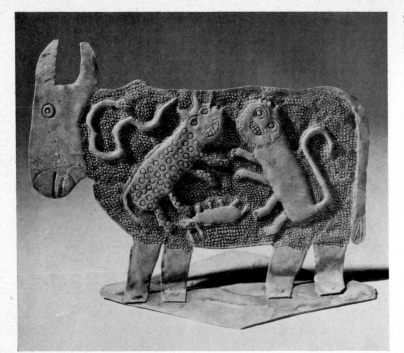

92 Asiru Olatunde
Cow (Oshogbo), 1962.
5 in. Beaten copper.

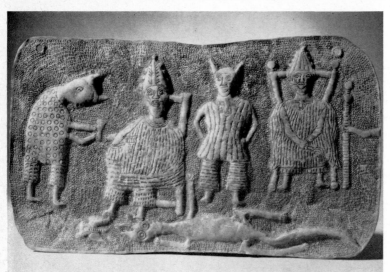

93 Asiru Olatunde
Homage to the King
(Oshogbo), 1962. 6 in.
Copper.

then tried larger animals that could be stood on a table like a toy. One day Susanne Wenger suggested to him that the body of these animals could be worked in relief to produce a more interesting composition and texture. Asiru then produced a cow in whose belly a leopard was seen struggling with a lion and an elephant whose bulky body served as background for a Yoruba chief accompanied by his dog. These could be called his first characteristic works and from then on development was rapid. Like Adebisi Akanji he had moved from craft and folk art to become an individual artist. He then began to make relief panels in copper and later moved on to large works in

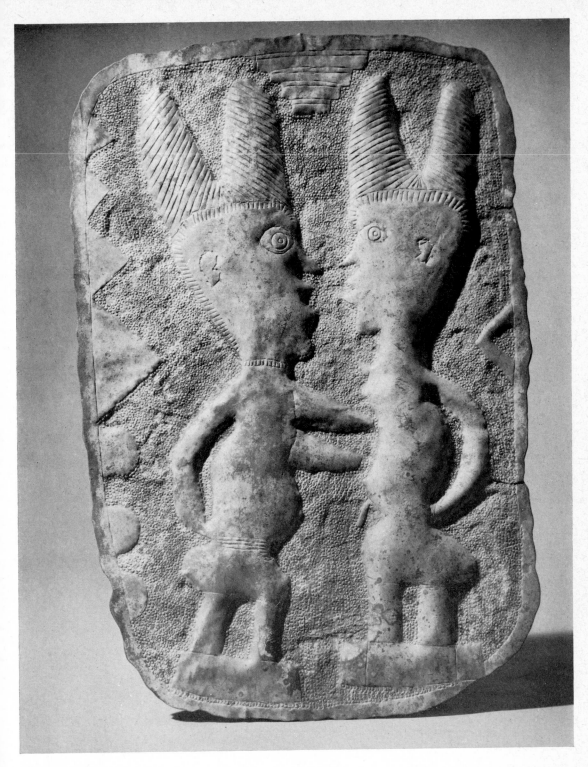

94 Asiru Olatunde
Man and Woman (Oshogbo),
1963. 12 in. Copper.

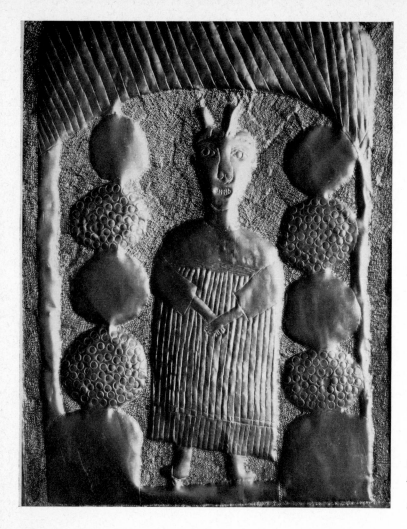

95 Asiru Olatunde
A Woman in Her House
(Oshogbo), 1963. 12 in.
Aluminium.

aluminium. He was quite obviously not short of ideas, but the immediate problem was to protect him from the dangers of a tourist market. In his early career he had been stuck with ear-rings because that was the only thing his Yoruba clients wanted. Now the very popularity of his work among Europeans threatened to kill it prematurely at any given stage. Had somebody turned up to commission twenty brooches, Asiru would have turned them out mechanically. For too long he had suffered from poverty. He could never have dared to turn down such commissions at that stage. To avoid this situation I bought every one of his works for nearly two years. The temporary strain on my purse paid wonderful dividends in artistic terms. Having only one client, Asiru could not repeat himself. He had to think of new ideas all the time and he always had ideas in profusion. Within a relatively short time his style and artistic integrity were so firmly established that it was quite safe to publicise his work widely and let him

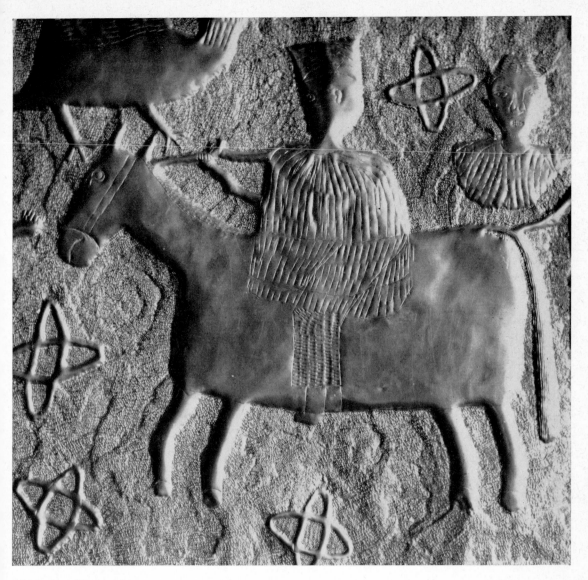

96 Asiru Olatunde
Horseman (Oshogbo), 1964.
15 in. Aluminium.

deal with his clients directly. The magic charm of these panels is not easy to analyse.

In his large compositions Asiru created a strange dream world, in which the descriptive, the decorative and surreal are wonderfully mixed. Superficially his work is illustrative or even pure story telling: the king sits in state under his umbrella, attended by flute players and wives; a rich man proudly stands in the doorway of his newly built house; women are pounding yam; the Fulani warriors invade Oshogbo; Jonah is eaten by the Whale; priests light the sixteen oil lamps of the Ifa oracle. But such simple descriptive themes never get boring because Asiru has a delicate sense of design and organises these events into a controlled decorative

97 Asiru Olatunde
Cocoa picking (Oshogbo),
1964. 15 in. Aluminium.

pattern. His sense of decoration is stronger than his sense of reality: the size of his figures depends on their importance in the composition, not on perspective. He imposes designs on top of each other: the bodies of cows and elephants are alive with other creatures that have been superimposed. On his large panels the static, severe composition into which he weaves his numerous figures is reminiscent of medieval tapestry.

At first the work may look detached. Asiru's panels never impose themselves on the onlooker. In this respect they are like the artist himself, who is quiet, soft-spoken, gentle—almost self-effacing. Yet he has considerable *presence*. And a second look at an Asiru panel also reveals this presence and the unmistakably personal touch: the line of his drawing is nervous, vibrating and sensitive. His panels have a strange background texture that is not suggestive of air or landscape, but produces an unreal, dreamlike atmosphere. He is full of the strangest, unrealistic ideas: he can suggest a 'house' by an ornamental pattern that is built of the conical shapes of the sun-dried bricks that are its components. His work is often very poetic: softplumed, long-necked birds glide through his forests; the Whale that swallows Jonah is a mythological creature, like something from a medieval bestiary. A sense of sadness pervades it all: the people who move through his copper and aluminium panels are lonely. The masqueraders seem overawed by their own sacred role; friends greet each other, but do not seem to reach; the rich woman stands alone and forsaken in her splendid new house.

No artist in Oshogbo has been more successful. And I do not simply mean commercial success. Some of the middle-class English customers may simply like his panels because they are 'typically African' and at the same time discreet enough to fit over the mantelpiece of their suburban homes, and aluminium seems to go with any colour wallpaper! Asiru's success has been deeper than that. His work is appreciated as much by illiterate people in Oshogbo as by European artists or art experts. Few African artists can boast of having sold a work to a market woman—as Asiru did during his Lagos exhibition in 1964. Asiru has carried out work for churches, palaces, banks, bars, universities and innumerable private collectors.

Of all the artists in Oshogbo he is closest to Adebisi Akanji. In their different media they are both chroniclers of Yoruba life. The mixture of the fantastic and the commonplace is present in both. Unlike the world of Malangatana, theirs is a

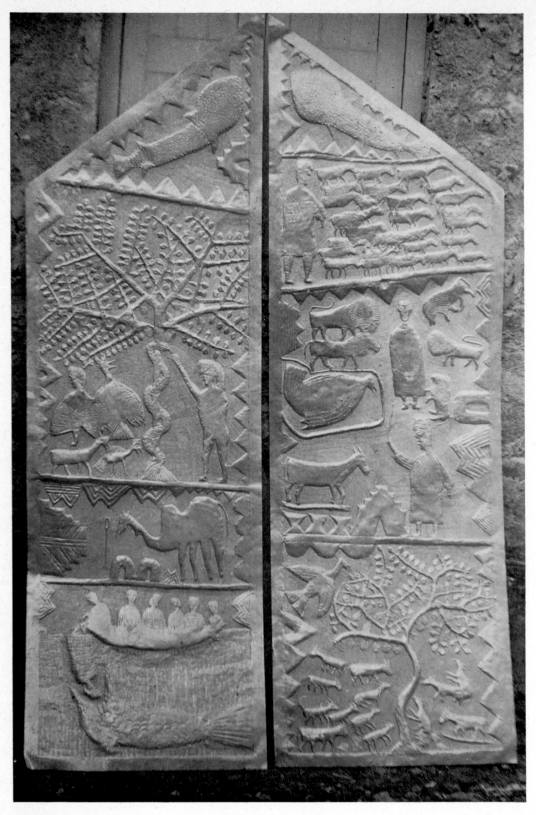

98 Asiru Olatunde
Church doors, *Adam and Eve* (Oshogbo), 1966. 7 ft.

The Camel and the Needle's Eye, Jonah and the Whale, The Good Shepherd,

Daniel in the Lions' Den, Balaam's Ass, The Sour Grapes. The fish at the top is the symbol of God.

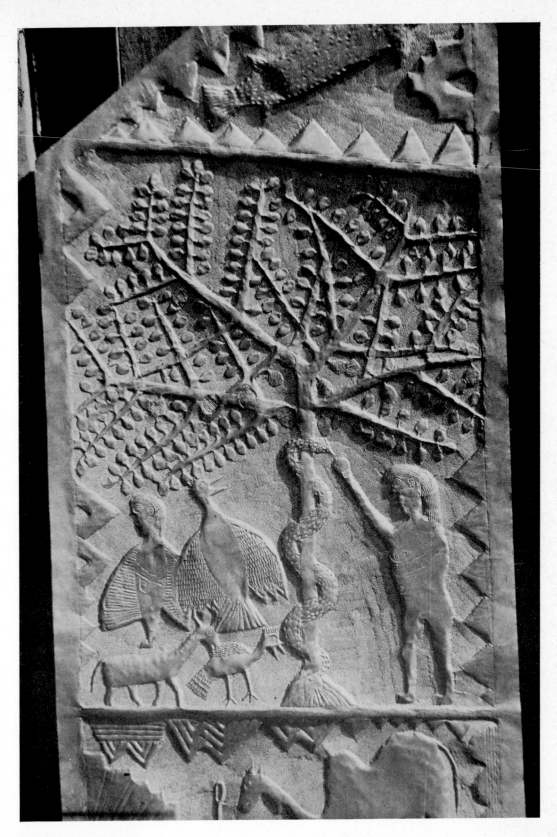

99 Asiru Olatunde
Adam and Eve (Oshogbo).
Detail of Plate 98.

world without fear and horror, a world in which the super-natural is familiar rather than uncanny. But whereas Adebisi Akanji describes this world with baroque energy and en-thusiasm, the mood of Asiru's panels is quiet and reflective, a little reserved perhaps, but friendly. Asiru was the first artist to emerge in Oshogbo and he is still perhaps the most widely known.

The sudden growth of Oshogbo as one of Nigeria's import-ant art centres is due to a series of happy circumstances. There is a rich traditional culture of which many aspects have survived colonial rule, modernisation and independence. There is a sympathetic ruler, the natural talent of the people and a large restless class of imaginative but unemployable school leavers. There are numerous Yoruba theatre companies which not only raised the general cultural level of the town, but also created an immediate demand for local artists and designers. There is the Mbari Mbayo Club and the proximity of two universities—not too near to squash local initiative, yet near enough to provide a ready market for artists' work. And finally there was the unusual circumstance of two European artists settling in the same town, both in different ways highly sympathetic to local culture.

All these circumstances working together produced a community of artists that could develop on many different lines and whose primary activities could be directed towards the community itself rather than to the fluctuating, transient tourist market or the commercialised art world of Europe or America. The artists described in the previous three chapters did receive considerable stimulus from outside, but unlike some rather more self-consciously 'African' artists they remained integrated members of their own society and their work feeds on local life and ideas, even if some of it has acquired universal significance.

Conclusion

In this book I have described a number of isolated developments taking place in different parts of Africa. Art schools, workshops, individuals, have developed on different lines. Some of the artists are hardly aware of the existence of others in parts of Africa remote to them. Some are more interested in the artistic developments of Europe than in their African colleagues. A few meet at international conferences, try to learn about each other, and keep in touch.

Do all the isolated phenomena add up to a movement or a style? Is there enough in common between these various artists to justify our talking about a Neo-African art? The term 'Neo-African' was coined by Janheinz Jahn and was originally applied to literature. Jahn's concept in turn was based on the literary movement of *Négritude* which flourished in the former French West African colonies in the thirties and forties. *Négritude* was the French African answer to the colonial policy of assimilation and to the sudden awareness of the Africans that they had been Frenchified to an alarming degree. To combat this process and to re-establish their identity they decided to go back to the sources, to learn from traditional culture, and to proclaim in their work the mysterious qualities to be found in Africa alone. It was a process of deliberate mystification, but it did produce two decades of inspired literature, even though the woolly quality of Africanness was never clearly defined. The myth rested on the assumption that cultures as diverse as say, the Dogon of Mali, the Yoruba of Nigeria and the Zulu of South Africa had certain elements in common which were *African* and which distinguished them from cultures in other parts of the world. The *Négritude* writers felt that they were distilling this quality in the philosophy of *Négritude*. Léopold Senghor has at various times defined *Négritude* as the 'cultural heritage, values and spirit of Negro-African civilisation', as 'a confirmation of being', as 'a self-assertion through negation', as

'a tool of liberation', and as a 'style rather than a theme' in literature. Jahn asserts that the distinguishing mark of the Neo-African writer is his style and he analyses Senghor's rhythms in his *History of Neo-African Literature* to prove they are derived from patterns prevalent in African traditional poetry. Jahn presented a strong case, which was, however, widely challenged. It was pointed out that many traditional elements of style—tonal patterns, for example—cannot be transplanted into European languages.

But even if there is no scholarly basis to the philosophy of *Négritude*, it does not mean that it was not valid as an inspiration, and its mystique was certainly responsible for the birth of contemporary literature in Africa. It is significant that the more pragmatic English-speaking writers have dissociated themselves from the movement and at a conference in Kampala in 1962 they arrived at the most non-committal definition of African literature conceivable: 'African literature is literature written by an African'. Their different stand can be explained partly by the fact that the British—with their system of indirect rule—did not pursue a policy of assimilation and there was no need to reassert values that had never quite been lost. Secondly, new writing in Nigeria and Ghana began considerably later than the *Négritude* literature of Senegal or the Cameroons. It began when independence was imminent and when the writer did not need to use literature 'as a tool of liberation' or as a form of 'self-assertion through negation'. To writers like Chinua Achebe and Wole Soyinka traditional culture and literature were simply another dimension they could explore if they wished, an added richness of background that was there to be used. At no time did they consider it to be the source of all true inspiration or the sacred trust they had to hand on to future generations.

The visual arts in Africa produced no movement comparable to *Négritude*. Two obvious reasons for this are that the French territories played a far less important role in the development of the visual arts than they did in the field of literature, and that the sudden revival of painting and sculpture took place just after 1960, the great year of independence, a time when even in the former French territories the *Négritude* movement had lost ground. On the whole the artists, as is natural, have been less vocal than the writers and less inclined to prop up their creative work with theories. The older generation of artists was an exception, since Ben Enwonwu of Nigeria and the late Kofi Antubam of Ghana liked to talk about their work and about African art in general.

In a sense it was expected of them, because they both held official positions in their countries and were expected to represent their governments at conferences. Artists of that generation were sometimes influenced by the ideas of *Négritude* or by Kwame Nkrumah's equally vague concept of the 'African Personality'. Nkrumah's 'African Personality' was a perfectly valid political myth, obviously intended to create a sense of unity and to nourish the Pan-African movement. Applied to the field of art it sometimes led to a peculiar theory which assumed that there was an undefined mysterious quality in African art that could be 'understood' only by Africans—and for some reason or other it could not be explained to outsiders. The implication is that only Africans are entitled to write or talk about African art because Europeans are incapable of interpreting its symbolism. I have myself been accused of being a poacher on the sacred hunting ground of African art, which is the preserve of the official court painters in emergent nations. Taken to its logical conclusion this view makes nonsense of African art: it loses its main function which is communication, and it becomes a secret code understood and jealously guarded by a small group of initiates.

Such views are not shared by many African artists. Many of them may regret and rightly so that art criticism is a field hardly explored by Africans themselves at the moment, but they certainly want to communicate. They look for their public and for a response anywhere in the world. African artists have a varied cultural heritage and their attitude to this heritage differs widely. A sculptor like Boira Mteki of Rhodesia comes from a culture that has hardly any artistic tradition, while one like Festus Idehen of Benin comes from a culture whose artistic tradition is oppressively powerful. A painter like Uche Okeke tries to come to terms with the traditional culture of his own Ibo tribe. Skunder of Ethiopia felt he could only become an artist through a painful process of alienation from his native culture. Salahi of Khartoum clearly looked to traditions outside his own for inspiration. Demas Nwoko feels free to adopt the two-thousand-year-old Nok terracottas as a valid tradition to build on.

These artists have been exposed to European influences in varying degrees. Some have studied in Paris and London. Some have gone to European-type art schools in their own countries. Others again were stimulated by an individual European artist. A few have felt no direct influence at all, but there is none who has not been exposed to European

advertising, industrial design and the cinema. The artists'
attitudes to these influences have also varied a great deal.
Some have regarded them as impositions and have fought
them consciously. Others have accepted them, as they have
accepted the colonial language simply as a useful means of
expression. Others have been naturally immune to any kind
of influence. Some did not give the matter a thought and do
not care. A few wish to identify themselves as 'African'
artists—others refuse to be pigeon-holed and assert that they
are artists who happen to be Africans.

The end results are more significant than the conscious
attitudes. What common elements can we detect by looking at
the creative output of African artists rather than by listening
to their professed beliefs and theories? A few generalisations
can perhaps be made. The more powerful African artists are
drawn to expressionist or surrealist forms. There is very little
genuine abstraction and no naturalistic art of any importance.
Most African art is not *engagé* in any political sense, but on
the whole the African artist 'has something to say', even if he
doesn't have a 'message'. Most African artists are more con-
cerned with their statement than with formalistic experiment.
Many stick to a certain medium and a certain style when they
find it a satisfactory vehicle for their ideas. Much European
art has become involved in a ceaseless search for new formal
ideas and even gimmicks. The absence of this feverish activity
in Africa merely results from the fact that there is a first
generation of artists who have not yet established a conven-
tion, let alone worn out their imagery. There is a freshness of
vision that is not naïve but which springs from the very
newness of this art.

The impact of Europe and the break-up of tribal society
can be compared to a stunning blow that knocked the African
unconscious for a while. Now, after a generation or two of
artistic blackout he is awakening from a trance, the world
looks new and changed to him and we watch him trying to
find his way about. Memories surge up which he wants to
capture quickly before they vanish and the new and foreign
impressions have to be digested and absorbed. Traditional
imagery sometimes serves him as a yardstick with which to
measure the foreign ideas that are fast becoming part of him.
Superficially a common vocabulary can be detected among
many of these artists: the mask, the sacrifice, spirits, and
folklore, form the elements from which the new individual
mythologies are being built. But even here we should be
careful not to draw hasty conclusions. The way in which

this mythological vocabulary is used differs considerably from artist to artist. A painter like Uche Okeke collects and then illustrates Ibo folklore. An artist like Valente Malangatana is haunted by the distorted remnants of Shona religion. Skunder Boghossian rejects the mythology of his native country in favour of a purely personal myth of his own. Twins Seven-Seven, perhaps the most fantastic of them all, is simply reporting his vision, like a landscape painter recording the natural phenomena he sees.

Much that is bizarre, exotic and mysterious in African art is so only to us, as foreign observers. The African artist may use such elements as naturally as Chagall refers to the rabbis, cows, lovers, horse carts and Orthodox churches of Vitebsk. In the case of Chagall the exotic fascination of his imagery has begun to wear off after sixty years of familiarity and we are now in a position to assess him more objectively as a great painter and enchanter. Much African art is perhaps admired and purchased in Europe and America for the wrong reasons. The attraction of the foreign, the exotic, the new, will wear off and could leave the collector in the end with platitudinous statement, feeble composition and flat paint. For in the end this art must be judged by the same criteria as any other. It is irrelevant whether we get the mysterious African message that only the in-group is supposed to understand. A painting has to 'work' and composition, colour, and texture are employed by all artists, African and non-African, to make it work. Subjected to the universal criteria, much of the new African art will stand up to the test. The best of it has universal appeal because it is not allegorical in the sense that each sign arbitrarily stands for a hidden meaning that has to be learnt. It is symbolical and has all the ambivalence of the true symbol that may produce different responses in different persons and allows for more than one valid interpretation.

Although I have attempted a few generalisations I do not feel that one can theorise as yet about Neo-African art. The very variety and diversity of this art is one of its most exciting features. We can speak of modern art *in* Africa, but so far these artists are too individualistic to be pigeon-holed as 'African artists'. Nor does it matter how we label them. *Today* Artists from different parts of Africa and from differing backgrounds are widening our vision and enriching our aesthetic experience. They are gaining recognition from critics in all quarters of the globe, and are beginning to make their impact felt in the international world of art.

Index

Italic references give plate numbers